Co-Published by

ECW PRESS
2120 Queen Street East, Suite 200, Toronto, Ontario, Canada M4E 1E2

SEKONDHAND PROJECTS
P.O. Box 71, Station D, Montreal, Quebec, Canada H3K 3B9 Attn: Paul Labonté

LIBRARY AND ARCHIVES CANADA CATALOGUING IN PUBLICATION
Paul 107
Bully: it's the pits / Paul 107.
ISBN 1-55022-663-0
1. Pit bull terriers. I. Title.
SF429.P58P38 2004 636.755'9 C2004-902598-8

Production: Sekondhand Projects
Art direction: Paul 107 and Marco Cibola
Design and illustration: Marco Cibola
Principal photography: Paul 107
Editor: Matthew Ferguson
Pre-Production: Sekondhand Projects/Emma Mckay
Printing: Book Art/Paramount
Front cover design: Marco Cibola
Front cover photo: Paul 107

The publication of *Bully: It's the Pits* has been generously supported
by the Canada Council, the Ontario Arts Council, and the Government of Canada through the Book Publishing Industry Development Program.
Canadä

DISTRIBUTION

Canada: Jaguar Book Group, 100 Armstrong Avenue, Georgetown, ON L7G 5S4

United States: Independent Publishers Group, 814 North Franklin Street, Chicago, Illinois 60610

Europe: Turnaround Publisher Services, Unit 3, Olympia Trading Estate, Coburg Road, Wood Green, London N22 6TZ

Australia and New Zealand: Wakefield Press, 1 The Parade West (Box 2266),
Kent Town, South Australia 5071

PRINTED AND BOUND IN HONG KONG

ECW PRESS

bully

IT'S THE PITS
PAUL 107

ECW PRESS / SEKONDHAND PROJECTS

Contributors (Photos, Illustrations, Text, Insight, Patience):

Paul Labonté, Marco Cibola, Jean Labourdette, Ted Power, Silvio Magaglio, Marie Rose Mourou, Eric Bailey, Diane Jessup, Matt Ferguson, Pen One, Kid Koala, Francois "Tchug" Leandre, Willo, Chris Wellard, Benny Tour, Pat Hamou, Drew Allan, Marcos Chin, Dave Delaney, Shadow Kennels, Fleur Hardy, Rare Species (Claudio & Justin), Scott Clyke, Pound Magazine, KAS, Shane & Pat and family at Gladiator Kennels, Chino/BYI, KR, Squibs Mercier, Andrew Pommier, Shawn Morrisson, Oli Van Roost, Rachel Granofsky, Rebel/SC, MPC Gagnon, Jack David, Thau Weva, Glife.ca, the staff at ECW, the people in my neighborhood.

Thank you Mom.

DISCLAIMER:

No dogs were hurt in making this book.
Sometimes dogs get hurt when they play.
This book was written straddling the thin line between fact and fiction. Everyone should follow the Animal Welfare Act of 1976. Before buying a dog, one should research and figure out if one is equipped to handle a dog. Before buying a dog, one should consider adopting a dog. One should contact organizations like Animal Farm Foundation (www.animalfarmfoundation.org) in the New York area or Bad Rap (www.badrap.org) in the Bay area. Even check out your local humane society. These dogs don't last long in the shelter system (they get killed). One should remember that before one goes out and spends big bucks on a puppy, it should never cost more than $500.

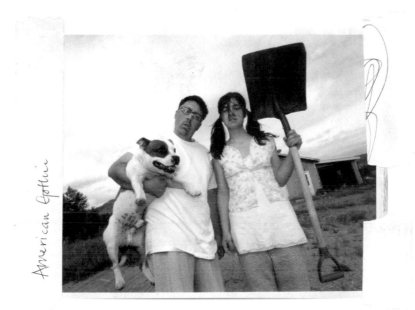

American Gothic

DEDICATED TO THE WINNERS AND THE LOSERS.

Intro:

The following I like to think will happen annually: it's a scrapbook of sorts, dedicated to the Bully breeds. We refer to it as "Volume One". Volume One is a celebration of Our Dogs, "The Grand Old Breed": the Staffordshire Bull Terrier; the Am Staff; the American Pit Bull Terrier; the Bulldog; the Pet Bull; the Nanny Dog; the Yankee Terrier; the people they love and the people who love them (as diverse as they are).

The book contains interviews with people I wanted to know more about, excerpts from conversations with the people in your neighborhood, photographs, illustrations, anecdotes ('cause everyone has an opinion), and some general info about the dogs, stuff that you can use in conversation and stuff that I think every new pet bull owner should know. It's stuff I have learned, wanted to know or picked up over the past year. The project's *sous-titre* is *It's the Pits*, not because at a certain point in the dog's history it was a pit fighting dog, but because in the last twenty to twenty-five years the mainstream media and irresponsible owners have tarnished this breed's storied past and tradition.

SO CONTRADICTION LEADS TO INSIGHT, RIGHT? LET'S GO.

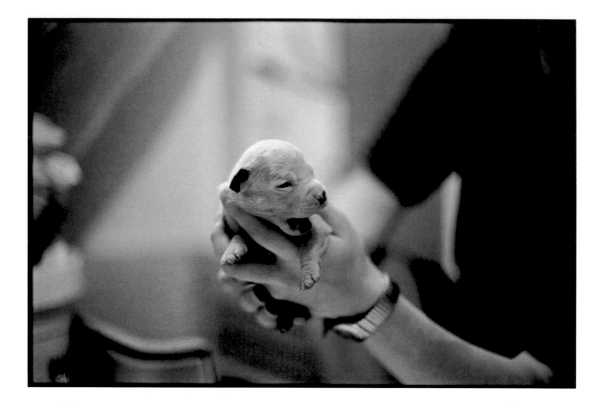

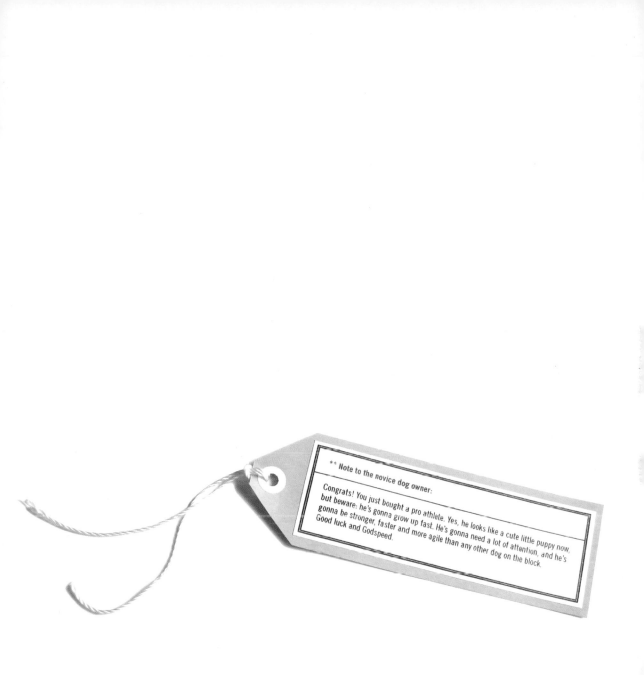

** Note to the novice dog owner:

Congrats! You just bought a pro athlete. Yes, he looks like a cute little puppy now, but beware: he's gonna grow up fast. He's gonna need a lot of attention, and he's gonna be stronger, faster and more agile than any other dog on the block. Good luck and Godspeed.

The art of bringing a puppy home.

Conversational exchange between
a mother and her son :

SON: I'm getting a puppy.

MOTHER: Like hell you are.

S: I'm getting a puppy, and it's going to live with us here.

M: I said *no*. Not in my house.

S: Well I'm getting the dog and if you wanna kick us both out, you're more than welcome to.

M: Have you finished with all this nonsense?

Son must walk away.
Son must return when Mother has cooled down.

S: So I bought a puppy. I'm picking it up next week. It's too late to cancel it, now that the ball is in play.

M: There will be no dog here.

S: We'll see next week when it's here. It's a cute little pit bull bitch. Won't be too big.

M: We don't have room for a dog.

S: Actually, these dogs are quite adaptable. They just need love and some good quality time with humans. It's a people dog. Can't wait – it's gonna be good.

Son must walk out of room before Mother can respond.
Bring the puppy home.
Hang out with the pup.
Introduce it to your mom.
Put the pup's kennel in your mom's kitchen.
Put the pup to sleep for the night in her kitchen.
You should wake up the next morning to find your mom sitting cross-legged on the floor playing with the pup.
It should be a cakewalk from there.

THIS IS ALL FACT:

The RCA dog, Nipper, was a pit bull. He was Thomas Edison's.
Jon Stewart has two pit bulls. Jon is a smart and funny guy.
Funny guys don't have dogs that would eat babies.
The Our Gang dog was a pit bull.
World War One poster art featured pit bulls.
And if you own a pit bull, you already know all of this.

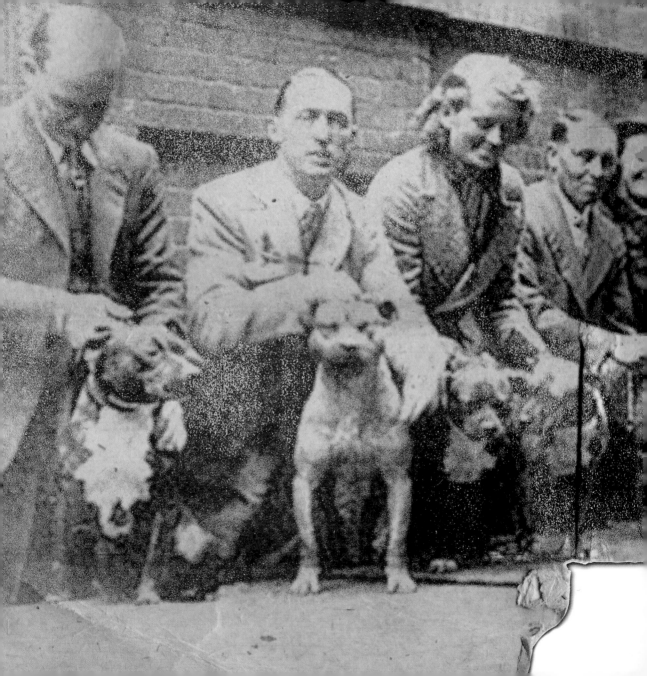

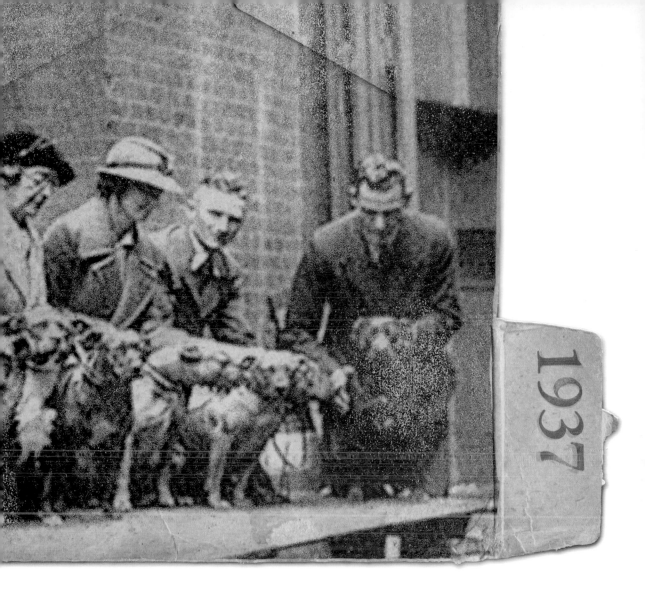

1937

Bulldog:
Years ago, the bulldog was the butcher's dog. He wasn't bred for looks, but for a job – to grip cattle. He was a catch dog. At one point, the butchers started getting into chats about whose dog could grip the best, and the sport of bullbaiting was born. People would come to watch; money was wagered. The sport was then outlawed. As a result, people started matching the dogs against one another.

The American Staffordshire Bull Terrier:
The American Staffordshire Bull Terrier is a dog bred for conformation. It was recognized as a breed in the 1930s. Conformation means it was bred for its appearance, and not its ability to work. It should be noted that the Am Staff's conformation standard is based on a Colby dog by the name of Primo, which, last time I checked, was an American Pit Bull Terrier.

The Staffordshire Bull Terrier:
The Stafford is often called the "nanny dog" in the UK.
They call it the nanny dog because it's great with the kids.
The Stafford was made by crossing the white terrier and the bulldog – the *real* bulldog, the *working* bulldog – not the show bulldog we know today.
The Stafford was bred to fight, and to co-exist with the family.
The Stafford was bred to be loyal.
The Stafford was bred to work and to finish the task it's been given.
People who own Staffords nowadays downplay – for the most part – the fact that the dog was once a fighting dog . . . a fighting dog that fought in a pit.
The pre-1935 Stafford was sometimes referred to as the "Pit Dog".
The pre-1935 Stafford was sometimes referred to as the "Bull and Terrier".
The Stafford is known to be bold, fearless and totally reliable. Read up on dogs. It doesn't say that about any other breed.

There are some Stafford enthusiasts/purists who believe that today's breeders focus too much on the bulldog attributes of the dogs, failing to recognize the importance of its terrier attributes.

Today's Stafford is bred for conformation. But it was once a working dog.

Of all the Bully breeds, the Staffy gets the raw deal. There are no accounts of a Staffy ever causing a human fatality in North America. There is not even a recorded attack on a human. But when the powers that be talk of banning breeds of dogs, the little Staffy is always included in the ban. Today's Staffordshire Bull Terrier is a show dog with a spotless track record.

The APBT (The American Pit Bull Terrier):
Contrary to popular belief, the American Pit Bull Terrier is a pure breed of dog.
The APBT was once referred to as the "Grand Old Breed".
The APBT was once referred to as the "Yankee Terrier".
The APBT is the best breed of dog on the planet. It can do anything any other breed of dog can do, only better. Weight pull, agility contests, rescue work, therapy work, shutzhund, police work – it doesn't matter; the APBT always dominates the field.
The APBT is the Pro Athlete of the dog world.
The APBT does not look for trouble. But it's ready for it.
The APBT makes a mighty fine catch dog.
The APBT aficionados often refer to the dog as the "bulldog".

**** The general public refers to, and recognizes, all these dogs as pit bulls; when in reality, they are all somewhat different. "Pit bull" in today's everyday language has a negative slant to it, when in reality, this breed of dog helped us to establish ourselves in North America, taking on the task of family protector, hunter and confidant.

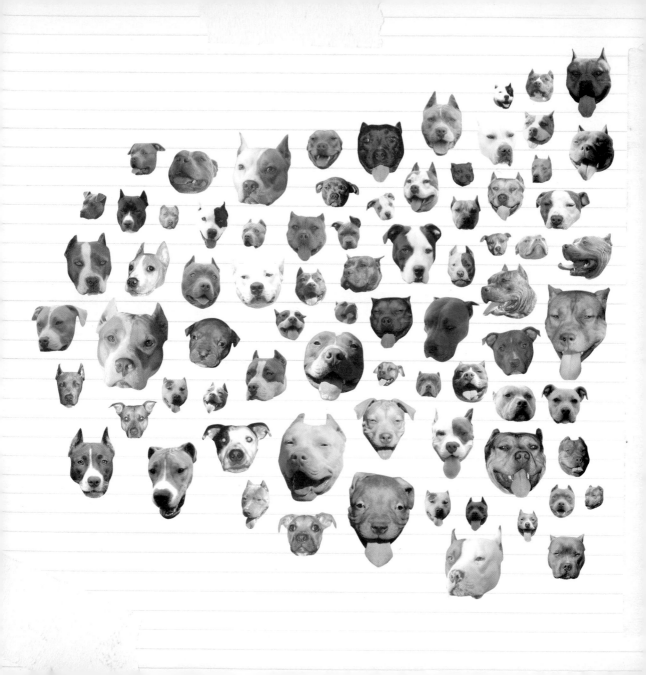

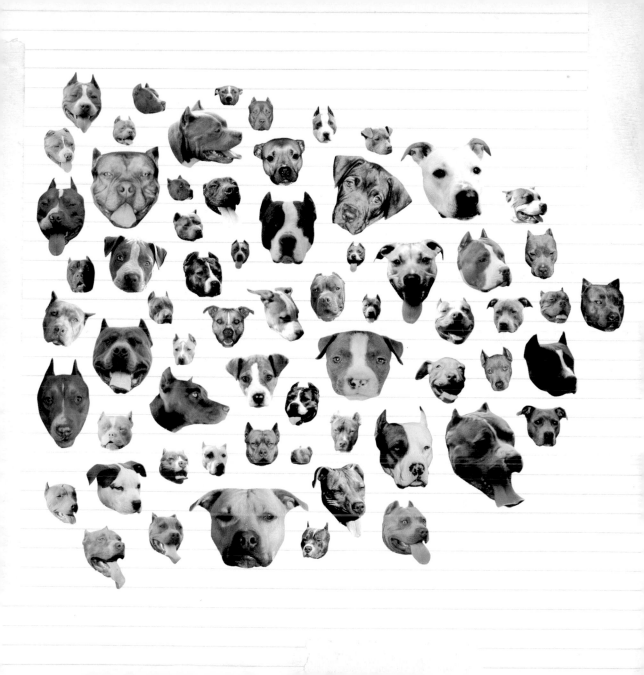

"THE STANDARD DOG OF THE U.S.A."

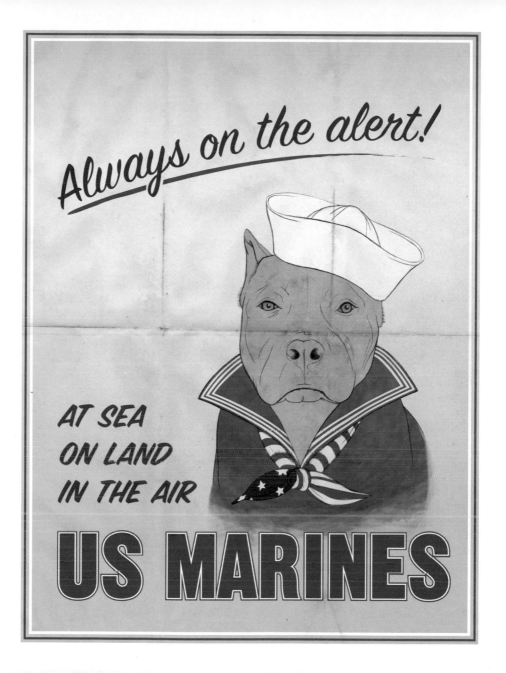

The Ideal Family Companion

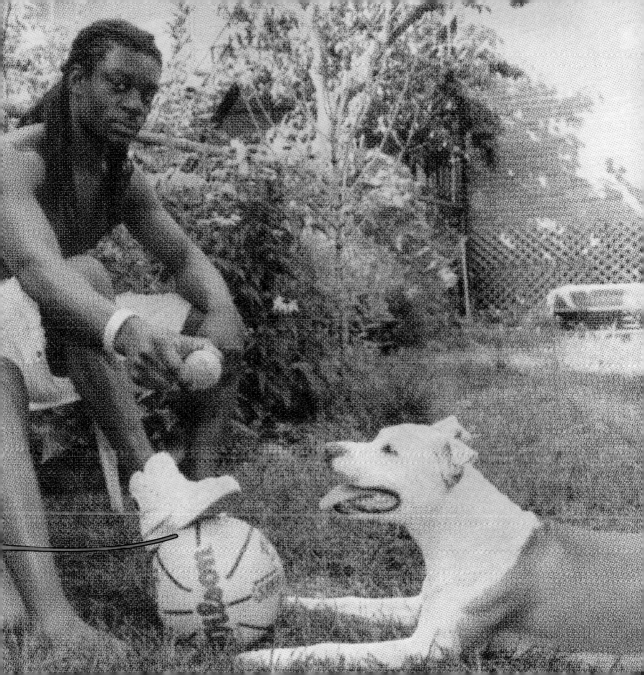

Housebreaking the Pup

What you need:
Newspaper, Patience, Kind Words and a Plan.

The Plan:
1. What you want to do is put a few squares of newspaper down in an isolated space. A room that accesses the outside world is best.

2. Put the paper down and get the pup familiar with it.

3. When you see the pup start to sniff around or squat like he's gonna relieve himself, scoop him up and put him on the paper. Celebrate with him when he hits the paper. He will start looking for the paper when he's gotta go – 'cause he loves the celebration.

4. When the dog starts going to the paper alone, start moving the paper towards the door.

5. Never stop celebrating successful trips to the newspaper.

6. Eventually, move the newspaper outside the door.

* **Any time a dog relieves itself outside, have an even bigger celebration than inside.**

** **A celebration involves petting the pup and telling him he is suuuuuuchhhh a gooooooood baby. It can sometimes involve a treat.**

*** **Bulldogs are smart. This process should take 3 to 6 days tops.**

The Program

Some people say that dogs should be out in the country and have space to roam. I say dogs should have responsible owners that get them to exercise regularly even if they live in a six-floor walk-up, shoebox-sized apartment in the heart of the city.

*** Summer warning: Achtung! The dogs often get caught up in their work and forget to stop and hydrate. This is problematic in the heat, so have water breaks regularly.**

Tug of War

The dog was born to grip and "shake it up". A friendly little game of tug of war is great exercise and a fun game you and your pooch can play together. The dog will like it more if you let him win sometimes. As fun as it is to swing the dog round and round, there really is no need for its hindquarters to leave the ground.

The Trees

It's a little-known fact that dogs, like squirrels, love to climb trees.

1. Make dog sit/stay. Show dog desirable object, e.g., stick, toy or a savory snack.
2. Place object in tree (not too high up at first).
3. Psych dog up. Whisper in his ear until he is worked into a frenzy.
4. Release dog.
5. Watch him fly up tree.
6. Prepare to catch him should he fall.
7. Repeat process daily, moving object higher.

*** Also works with fences. If your dog excels at this kind of stuff, agility contests might be something you and your dog should look into as a competitive activity.**

Fetch

Some dogs fetch; some don't.
The trick is to start the dog off with two balls.

1. Make dog sit/stay.
2. Throw the first ball.
3. When the dog has retrieved it – if he shows any interest in balls – show him the second ball to bait him into dropping the first.
4. Don't throw it until the dog has given up the first ball. Repeat the words "drop it" or "leave it".
5. Repeat the process until the dog starts returning the ball on command.

** **To ensure the ball's longevity, don't let the dog play with it when the game of fetch isn't going on. Also look into those orange street hockey balls; they aren't hard but at the same time they don't puncture easy. Plus you can buy them for peanuts.**

The fine folks from the dog park think you should know that tennis balls are full of chemicals that are bad for your dog. We on the other hand want you to know that if a tennis ball is ripped, your dog could swallow it. And if he or she did swallow it, it could get stuck in its intestines. If a ball gets stuck in your dog's intestines, it would most likely block the intestines and your dog would die slowly (and painfully). Your best bet would probably be to not let the dog go unsupervised with anything he or she could potentially swallow.

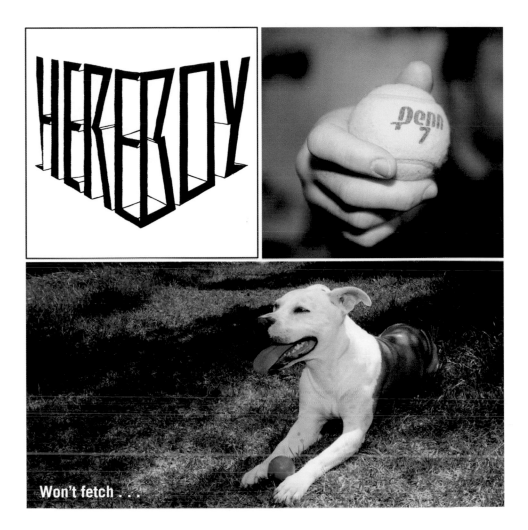

Won't fetch . . .

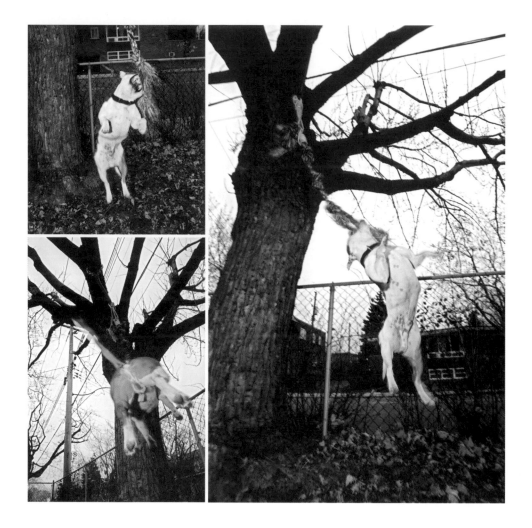

Springpole

What you need: A piece of rope, a garage door spring, a piece of chain, something to bite on. A piece of rawhide would be ideal, but anything else you have lying around should work. Government-issue ripstop army pant fabric has worked out great for me in the past, but you can also go with one of those knot ropes you find at the pet store that look like they should be on a naval vessel.

<--- Even Staffies like to get down with the springpole.

FYI: I have it from a pretty good source that every time a pit bull cross (A MUTT) bites someone, it goes down in the books as an American Pit Bull Terrier, which, last time we checked, is a recognized pure breed of dog. Just another way the stats related to these animals are skewed . . .

Weight Pull

Some people think it's cruel. Other people think it's a great alternative to fighting dogs to prove gameness. The experts want us to know that having a dog pull too young, or trying to make a dog that isn't interested in pulling pull, isn't going to work out for you

The experts would also like to add that you should invest in a harness that is made for pulling and that fits your pooch correctly, which is another good reason to wait till the dog is fully grown (the harnesses are a little pricey).

For pulling info, look into the International Weight Pull Association at www.iwpa.net

Note to human passersby and other assholes who choose to comment on something that doesn't concern them:

Some dogs are vocal when they play. They may be grunting and growling, but it doesn't mean shit. Is all the noise making you blind? Did you fail to notice the dog's tail going a mile a minute? Everyone's having a good time here – maybe if you let your dog socialize a little, instead of tightening up on the lead every time someone walked by, your dog might be cool around people and other dogs too.

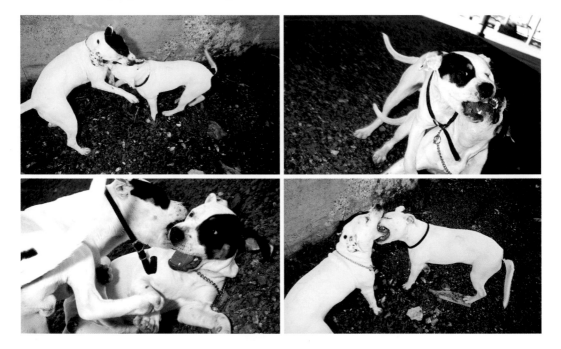

*** They claim that socializing your pup young will go a long way in its ability to get along with other creatures. Letting bulldogs play unsupervised, however, isn't the best of ideas.

Food

The tree huggers, the dog nutritionists, the in-the-know yuppies/hipsters right now are all screaming the praises for the raw food diet for your pooch. Euro Americans, i.e., the whites, are perhaps some of the most malnourished, well-fed folks on the planet, and the hipsters wanna feed the dogs with food another human could and should be eating . . . but I digress.

The raw food diet is ideal for your dog because it's a healthier alternative than most dry dog foods, and it is closer to what the dog would be eating in the wild. Bones and meat provide a lot of nutrition. Look into the BARF Diet (www.barfworld.com). I'm told BARF stands for Biologically Appropriate Raw Food. Dogs can't break down veggies, so if you intend on including them in the diet (because they are nutritious) you should blend them first.

The Deal on Dry Dog Food

In this day and age, companies are bought and sold on the regular. Companies changing hands means that ingredients, recipes and quality levels change as well. So what was the top of the line brand five years ago isn't necessarily made to the same standards today. As you can probably imagine, there is nothing good about a dog food that has actual dog parts in it, so make sure you're not feeding your dog the bottom of the barrel. Also, look out for chemicals. You should remember that breeders and veterinarians get sponsored by dog food companies, and endorse certain products as a result. So in the words of Stone Cold Steve Austin, "DTA" – Don't trust anyone. Do the research yourself.

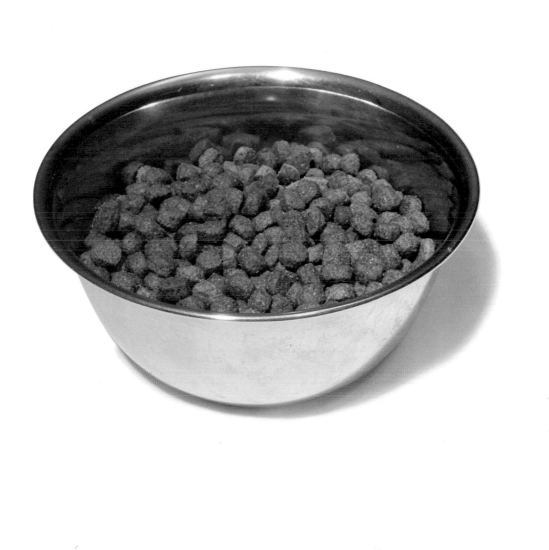

A Meal Fit for the President's Dog

This is all fact This French chef I know quit his job in France (a great job) and moved to North America to become a full-time graffiti writer. He once worked as a chef for the president of France. Along with preparing meals for the president and his guests, the chef also prepared meals for the president's medium-sized dog (which was not a pit bull). The dog ate well. He usually ate *filet de boeuf (filet mignon,* for the uninitiated) with carrots, rice, small peas and corn niblets, all diced to the same size and prepared with care. He repeated terms like "sautéed" and "caramelization of the meat" as he spoke about the preparation of the dog's food.

Secret to a Shiny Coat
Location: Montreal, St. Patrick's Day Parade 2002.
Courtesy of drunken rugby team from Ireland as they walk by the dog.

-Look.
-It's a Staffy.
-Look.
-Like at Home.
-That's a Staffy, yeah? Haven't seen any here. You know you must give 'em a spot of tea weekly to keep his coat nice and shiny. That's what me Gramms says.

They walk away. I didn't even have to speak.

Secret to a Shiny Coat: Part 2
A little Norwegian kelp in the food or a little flax seed oil in the food. Try twice, weekly.

Actually, from what I am told, flax seed oil is one of the greatest things on the planet, because it will "cure what ails you". Another gem brought to you by the fine folks at the dog run.

Anti-Diarrhea recipe:

1/2 banana
1 egg
Shavings off an Oxo cube
1 tablespoon of butter
1/4 cup of milk

Scramble together in frying pan. When cooked, add a good dollop of yogurt. For a bigger dog, add an extra egg.

So Necessary

The Breakstick
From the Dept. of Better Safe Than Sorry.

The breakstick is used to separate dogs once one has gripped onto another. It's a tool dogmen use. But it's a tool that any responsible bulldog owner should carry, as it will open a dog's jowls even if it is unwilling to release. The stick is oval-shaped. In some states it's outlawed and considered fighting paraphernalia, but it is effective and wonderful to have around IN CASE OF EMERGENCY. You might be thinking, "I have control of my dog and something like that will never happen to me, so I don't need one." Well what if someone else's bulldog gets a hold of your dog? Shit happens, even to the most responsible of dog owners.

How it works
1. Don't get between the dogs until one dog has a hold on the other.
2. Never tug on the dog; the dog's not letting go. You will only be contributing to the tearing of flesh.
3. If you are alone, tie one of the dogs to something.
4. Stand over the dog that isn't tied up. Hold it tight with your legs around its waist/back leg area.
5. Grab it by the collar.
6. Slide the stick in behind the molars, where the gap is.
7. Turn the stick. It's oval-shaped, so it will open up the jaw enough to pull the dog away.
8. Pull the dog out of harm's way.

**** You can also try flipping the dog on its back (stretching out its hindquarters). I have never seen this work, but apparently dogs really hate it and will sometimes release. I would also like to take this opportunity to remind you that "lockjaw" is a figment of the mainstream media's imagination. The dog has a powerful jaw with big muscles and the will to never give up. There is no locking mechanism, and the ten thousand pounds of bone-crushing power – as seen on TV – is also fallacy. We have no machines that can measure the power of a dog's bite.

Treadmill

Whenever you hear about a dogfighting bust on the news, it always seems to be during a drug bust, and they always seem to find dogfighting paraphernalia. It always seems to be a weight scale, a treadmill and breaksticks. Now last time I checked, weighing your dog wasn't a crime. And having gym equipment or a physical fitness center in your home isn't either.

A treadmill is great for getting or keeping your dog in shape. A little excessive? Maybe. But if you have the money, why not? The only thing you have to remember is that it's not a replacement for a walk. In fact, the time spent exercising the dog on a treadmill must be doubled right afterwards with time spent on a walk, so that the dog can cool down.

Check out the Colby family's carpet mills. They are like buying a piece of history. Or you can look up Chandler K9 conditioning equipment (www.chandlermills.com). They build slat mills and have something that will work with any size or shape of dog, from the thirteen-pound Patterdale to a big bulldog or Shepherd. They are great for getting or keeping your bulldog athlete in shape for his weight pull, agility or flyball tournament. What I really like about the Chandler mill is that the people over there really care about quality, performance and durability. They really take pride in their product and are always tweaking an already almost perfect machine.

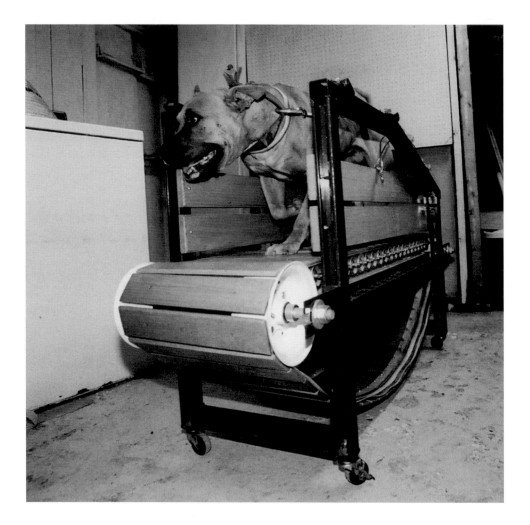

The Babysitter

1. Insert peanut butter, piece of meat, or dog treat.
2. Walk away from dog slowly.
3. Close door behind you.
4. Never make a big deal about coming or going.

* Hours of enjoyment; plus, a great jowl workout.

Available Color Ways.

The dogs are available in

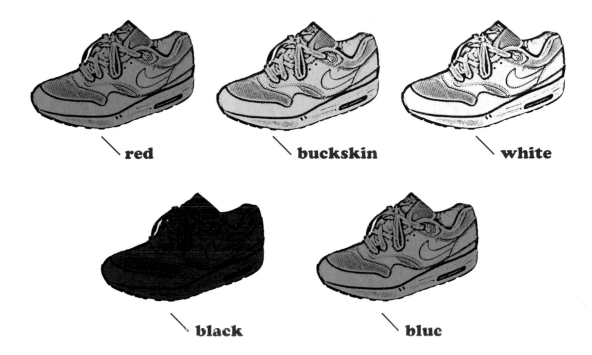

red buckskin white

black blue

. . . or any of these colors with white.
Any shade of brindle or any shade of brindle with white.

*Brindle is tawny brown, or gray,
marked with darker streaks or patches. . . .
It kinda looks like tiger striping.

And oh yeah . . .

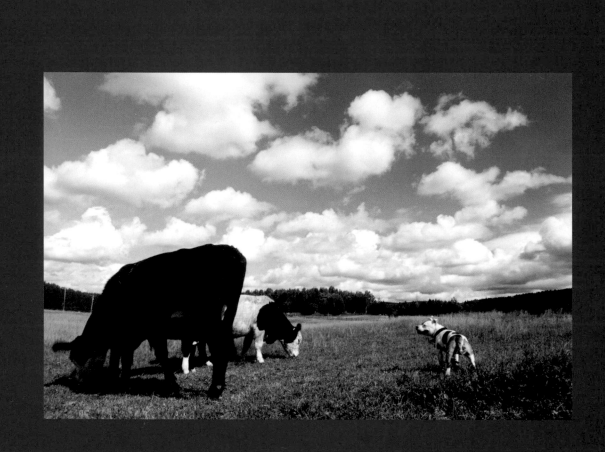

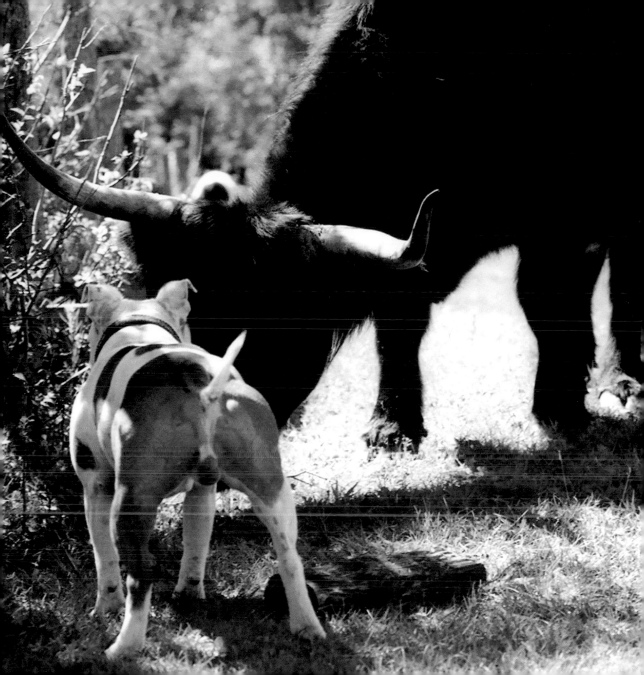

To: santa@northpole.com
From: marie@rockwood.com
Subject: what I want

DEER SANTA

I wood like a dog like my Nanny has for
christmas.ok.an old famly dog.
Thanks Santa.

Nanny says its a Rare Species.I will lov to
dress up the doggie.

Marie.xox

ED BOKS, New York City's Animal Care and Control Director, wants to rename the pit bull the New Yorkie.

I Googled the New Yorkie and found a web forum with people's thoughts on that. One guy thought they should rename the pit bull the Bronx Poodle.

I heard that 10,000 plt bulls a year get put into animal shelters in the New York City area alone. That means that 192 dogs a week are left homeless or that 27.39 dogs a day are abandoned.

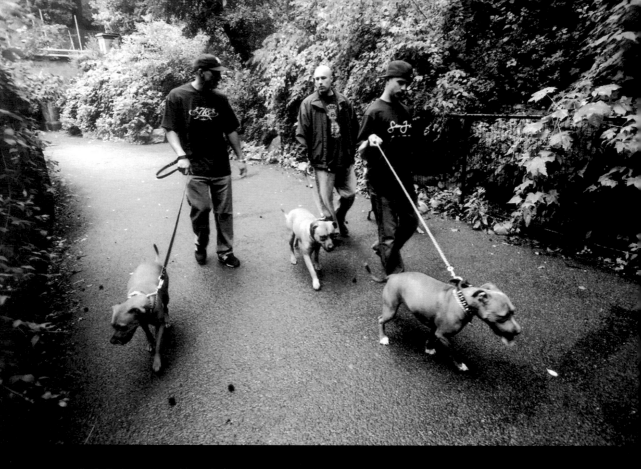

JUST A WALK IN THE PARK
PROSPECT PARK: BROOKLYN

When Dave's dog Samson died, it was a sad day. But a few weeks later, his boy Sent/ TMR, rolled through to hang out with Dave. When he got out of his truck, he showed Dave what he had in the back seat. It was a litter of puppies. A bunch of little red noses. They were puppies from his two dogs' first litter. Dave brought one of those puppies home. Her name was Penny. That was five years ago.

Penny's parents are Rocco and Lucy. Rocco is a Bass Tramp Red Boy. He is now six years old. Lucy, the bitch, is now a seven-and-a-half-year-old Martin Caesar Old Family Red.

I show up at Dave's house around lunchtime. He's polishing off some blueberry pancakes. We're going to Prospect Park to walk Penny, and hook up with Sent and his buddy Mario. It's an exciting day for Penny. She hasn't seen her parents since that fateful day five years ago.

About an hour later, we arrive at the park and the dogs are reunited. Big surprise: they don't recognize each other. But they definitely get along. The next three hours are spent exploring the park and engaging in epic games of fetch.

Imagine that: four pit bulls with three male owners, occupying the same space at the same time, and everyone getting along. A bit anticlimactic, isn't it?

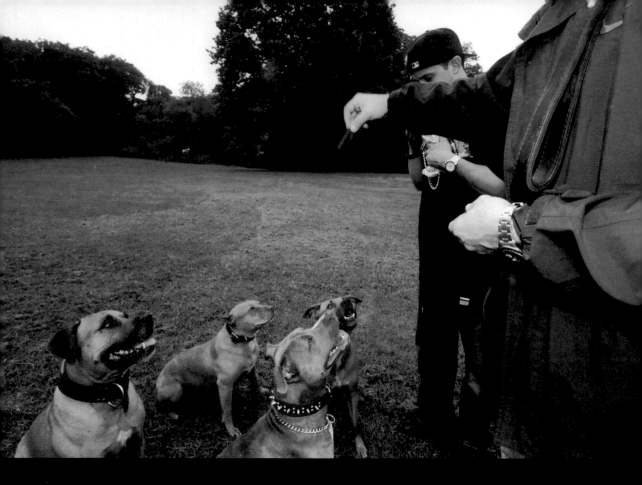

ABOUT THE PARK:

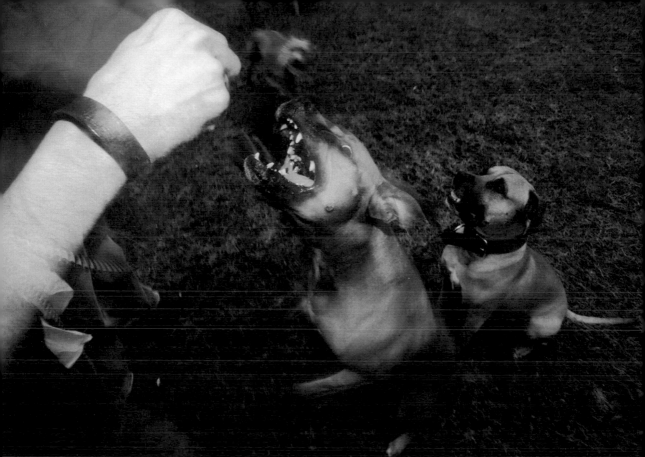

Prospect Park was designed by Law Olmstead and Calvert Vaux in the 1860s. They are also responsible for Central Park in Manhattan and Boston's Emerald Necklace. Prospect Park, however, is considered by all to be their crowning achievement. Go Brooklyn. There is a selection of over 150 different kinds of trees for your dog to relieve itself on in the park, including Black Cherrys, Norway and Sycamore Maples, Red Oaks and even some Sweet Gums.

The 526-acre park is set in the heart of Brooklyn. It has a zoo, a lake, a forest and a 60-acre meadow.

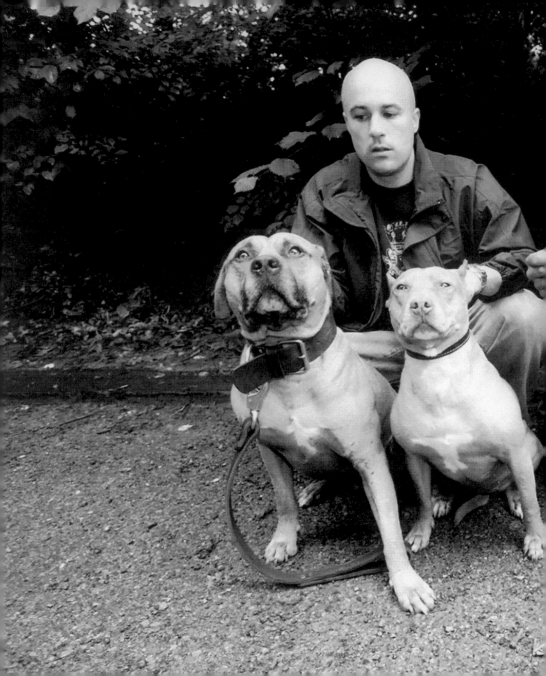

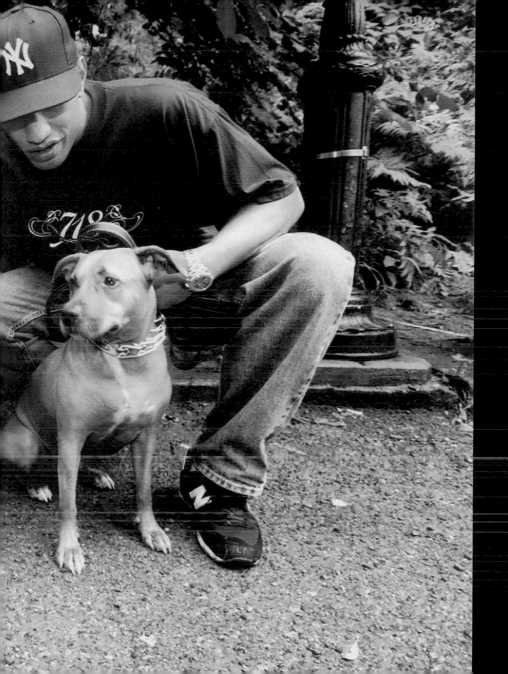

63

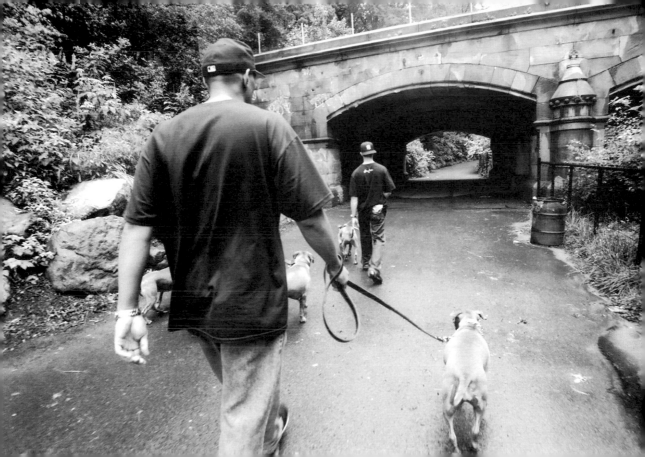

DAY TRIP: DOG SHOW

Journal Entry – June 2004
Rural Ontario

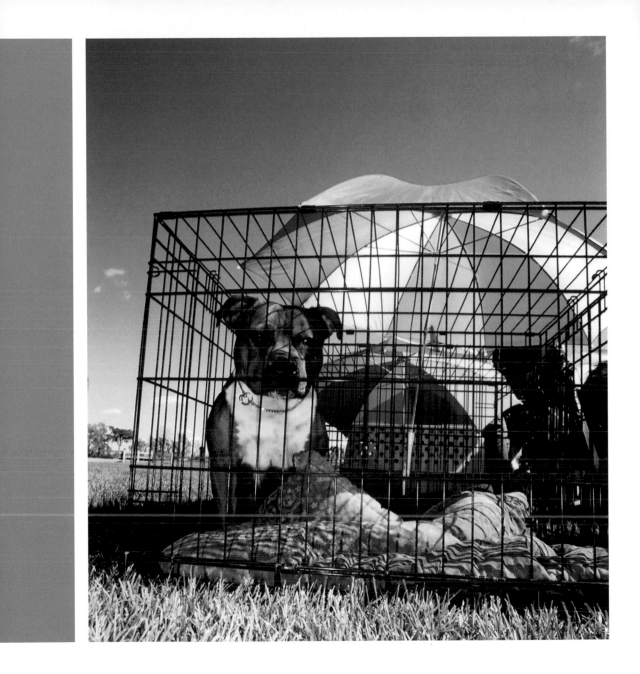

I went to a dog show today and watched a woman cry.
Her young dog won "Best Puppy", then "Best of the Breed" and then "Best of the
Group". She earned lots of points towards her dog's championship. All this in one
action-packed afternoon.

They were tears of joy. She has been competing for eight years and she finally has
a dog that will take her to the Promised Land.

The highlight of the day, though, wasn't the show or all the dogs. . . . I sat next
to and befriended a woman named Squibs. She showed up in a golf cart. Turns
out she is the VP of the Staffordshire Bull Terrier Club of Canada and one of its
founding members. She recently had knee or hip surgery. I learned early on in our
conversation that she skipped out on rehab to get home to take care of her two
aging Staffies. I asked her how she got into the dogs. Turns out she was originally
from England and her dad was a Staffy fancier before her. On why she loves this
particular breed, she listed off heart, smarts, loyalty and the fact that the dogs
don't look for trouble, but that they won't let themselves be pushed around.

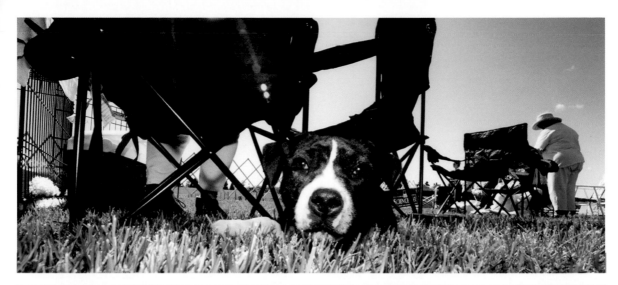

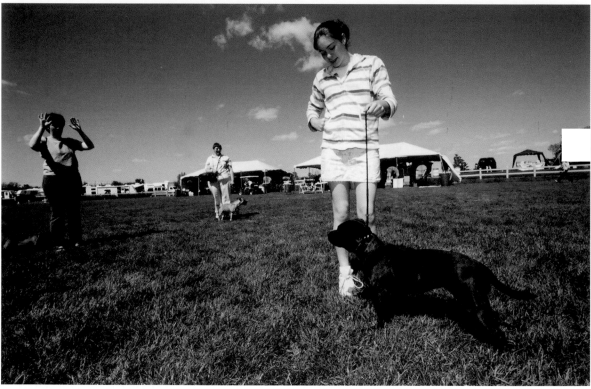

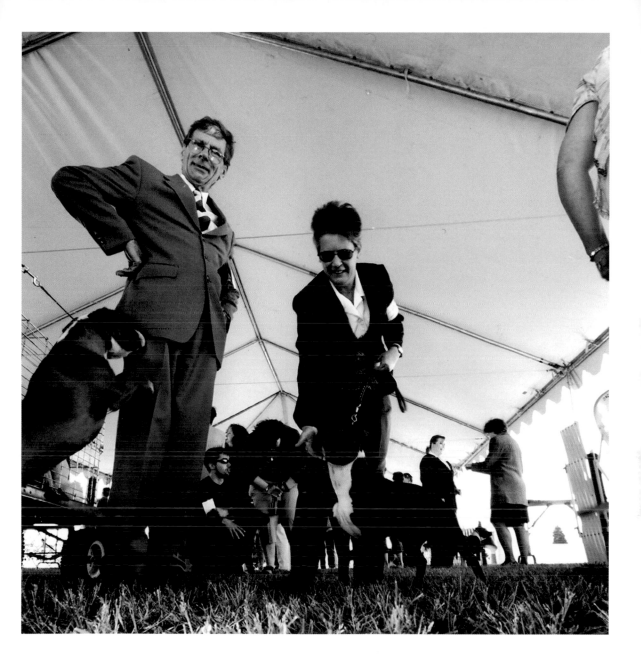

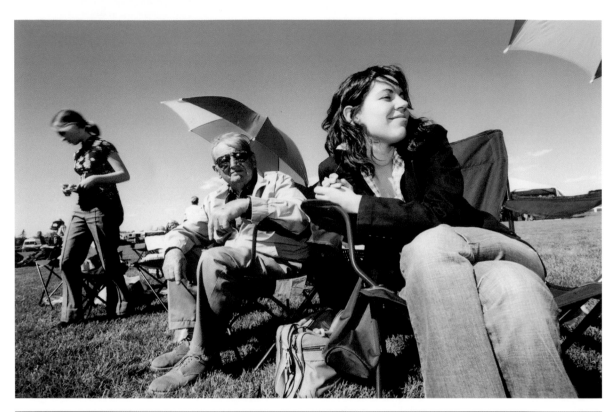

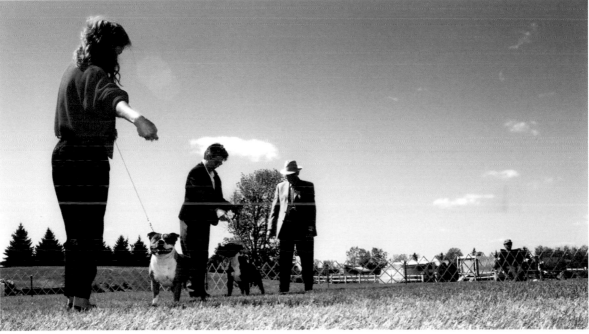

*** Interesting dog show fact ***
Most Staffy fanciers in Canada refuse to show their dogs with those skinny little nylon string dog show collars. Instead, they opt for the breed's traditional collar, which is a beautiful combination of leather and brass. The nicest ones I have found were made custom by AE Collars in the United Kingdom (www.aecollars.co.uk).

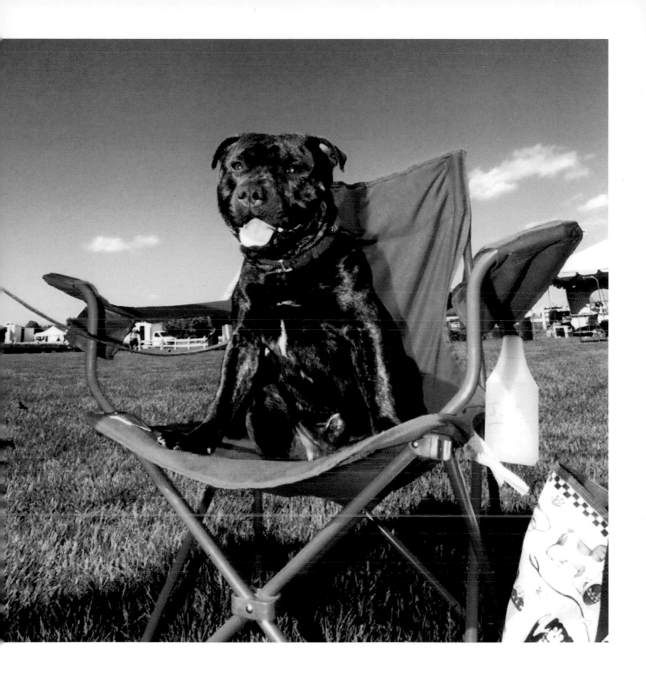

"Remember those t-shirts in the early '90s that read
'No White Lady, I don't want your purse?'
Yo, when I walk my dog some days, I feel that same vibe
coming off these women – and it's fucking wack
'cause I'm a church-going, God-fearing dude
that holds down a nine-to-five."

David Michaels, Detroit, Michigan

"We trained the dog to watch the house. There's a lot of
'B&E's' in the neighborhood, and we trained her
to handle that for us. If you walk in my house
and we ain't home, you got problems.
If I ever come home and my TV's gone, I promise you
I'm coming home to blood stains all over the walls."

Anonymous, Coney Island, Brooklyn

"Have you ever seen a real dog fight?
You don't want to, man. I don't care what anybody says!
A real fight is a $2,000 buy-in
and I don't care what anybody says; one of the two dogs
isn't leaving alive. It's not an easy thing to see.
It's just not worth it . . . "

Pat, outskirts of Montreal, Quebec

"I see a lot of young punks with these dogs that are
super aggressive towards other dogs. When they see another dog,
they get loud just to let you know that that doesn't mean shit.
It takes a special dog to keep fighting when the chips are stacked
against him and he's underneath. The kids don't know that.
and they should leave well enough alone."

Bill, upstate New York

"I don't know what all the fuss is about.
I have a house filled with four kids and two pits, a cat
and three hamsters. My dogs wouldn't hurt a fly.
In fact, they are both overweight. They're scared of
their own shadows. The doorbell rings and they run for
cover – and don't even get me started about
how scared they are of our cat . . . "

Kim Jacobson, Ypsilanti, Michigan

"Fifty years we have these dogs at home.
No problems. Good with kids. Good with grandkids.
Soon, will be good with great-grandkids, ha-ha-ha."

Drasko Prelevic, in suburb of Chicago, Illinois

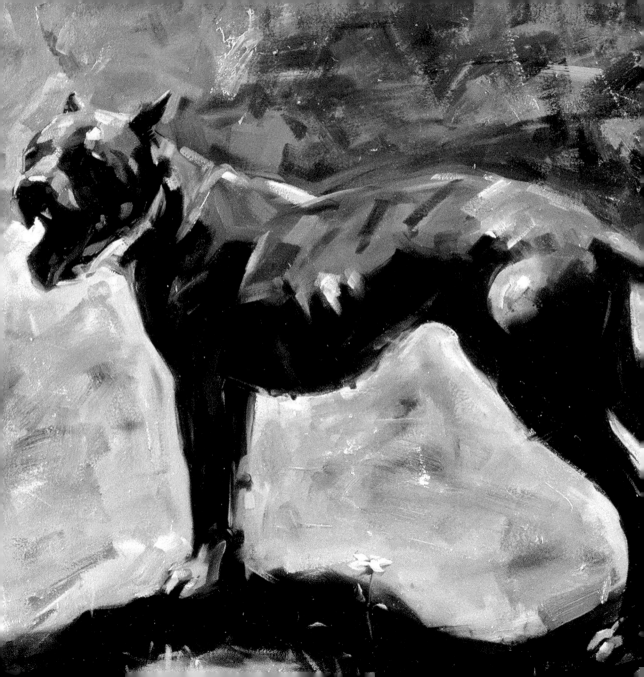

86

Previous: *Mother Nature Has a Guard Dog,*
2004, oil on canvas, 25"x25".

Right: *Ghost Dogg,* 2003,
oil on canvas, 48"x32".

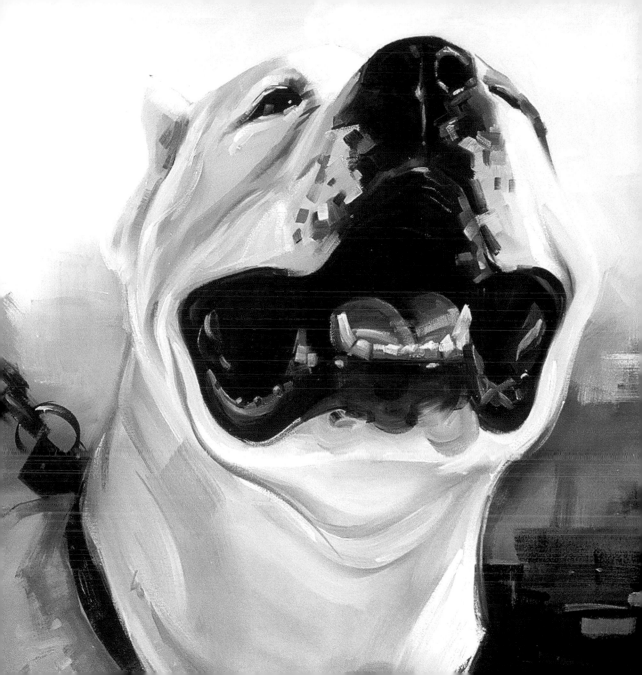

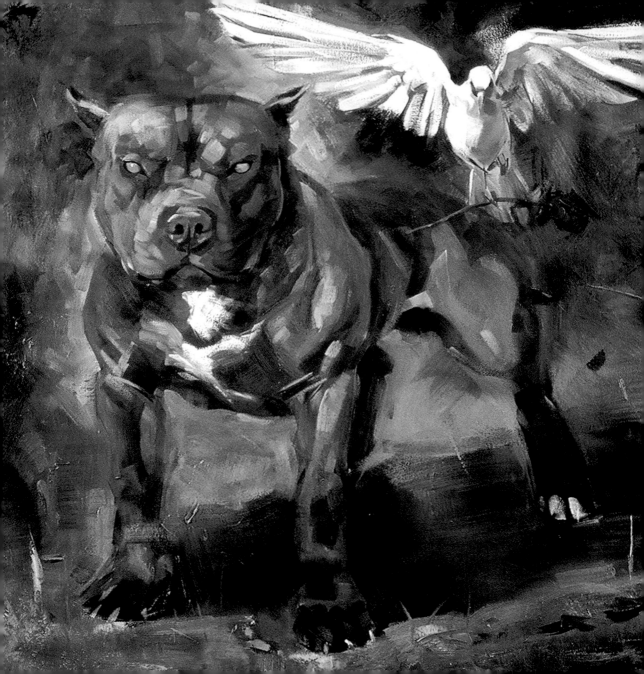

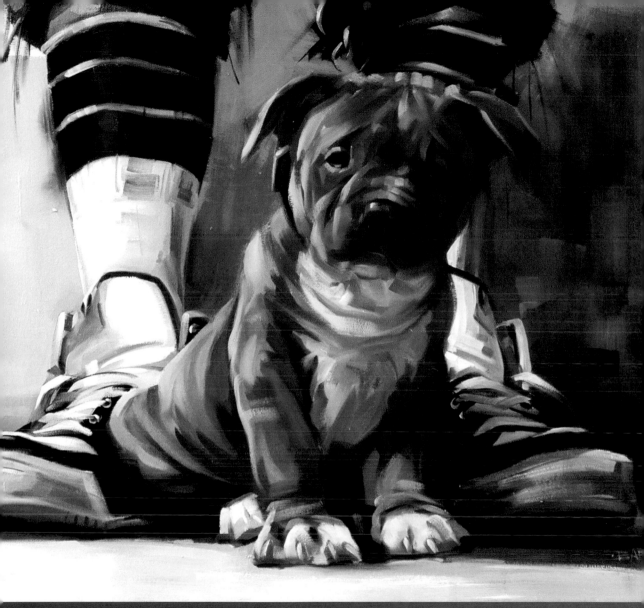

Above: *Gumbo*, 2004, oil on canvas, 34"x30".
Left: *Peace Has a Guard Dog*, 2004, oil on canvas, 25"x25".

Ted, 2003, oil on canvas, 72"x60".

How did you get into the dogs?

At first, I simply thought they were visually interesting: large heads, defined muscles, short coats, variations in colors. Dogs, especially pit bulls, are very beautifully designed animals. Being a painter, I am constantly examining things on a daily basis, searching for visually stimulating subjects to paint. Pit bulls just happened to catch my eye. Then my brother brought home a puppy named Gumbo. I fell in love and he's been my buddy ever since, as well one of my main subjects.

Why did you get this kind of dog?

Our good friend Yani occasionally breeds some of the most beautiful dogs with very kind temperaments. He had a litter fathered by his dog, a gentle giant named Ted, a.k.a. Head. Ted was a big influence in showing me that these dogs can be really good companions. We couldn't resist taking one into the family, and we chose Gumbo, who looks almost identical to his father. It was more of my brother's decision and dog – I'm more just like an uncle to him. However, down the road I plan on owning my own, probably one of Gumbo's offspring.

You should consider adopting. What do you think attracts people to this particular breed?

I think it's many reasons; some good, some bad. For instance, half the kids in my neighborhood want or own a pit bull, but I think it's more of an image thing than anything to them. Don't get me wrong, they are cool-looking dogs and it feels pretty nice to have one walking by your side. However, they are animals, not material items. Respect to the people who support the breed in more of a positive light.

Why paint them? What do they represent in your world?

Like I said earlier, it started more as just a visual thing to me, as do most of my paintings. Something needs to be visually stimulating to me before the subject matter or concept can be analyzed. Now, the dogs mean so much more to me. They are "man's best friend"; they bring joy and comfort into our lives, and vice versa. I like most dogs, especially larger breeds. However, to me, pits represent the ultimate companion; they are sweet, but also something not to mess with. There's a good balance about them, which I respect. This balance is found throughout most of my art. I paint happy/sad or dark/fun paintings, never just fluffy or demonic alone. As for what the paintings mean, that's up to you to decide. I know how they make me feel . . . and you may have a different view. That's what art's all about to me – it's completely opinionated.

ERIC BAILEY IS WWW.BIRDSANDBULLETS.COM

MADE TO MEASURE

DOGGSTAR CANINE DESIGN

Engineering Quality Handcrafted Collars.

Jonathan is a leatherworker. He makes dog collars that are of an unsurpassed quality. It doesn't matter if you need a basic two-inch wide collar for your yard, or you want him to create something intricate and absurd, or better yet, absurdly intricate. You can rest assured that your satisfaction is imperial. He is to the dog collar game what a custom bike builder is to the motorcycle industry.

When did you start making custom leather collars?

2001.

How did you get into it?

My dog was cold – it was, like, January – and I was having trouble finding her a decent sweater. I wasn't happy with anything I saw in the pet stores, so I ended up having a friend of mine make her something that I helped design. It was pretty hot. People freaked over it. Soon after, Doggstar Canine Design was born. The leather came later. The original idea was to put out a whole line of products under the Doggstar name, like everything from bowls to beds, to coats to keychains to leather gear.

My approach at the time was totally backwards because the government was dangling money in front of me and I was spending my days jumping through hoops. I needed their money. But even more, I needed the assistance they offered along with it. I mean, I had no fucking idea what I was doing! I had all sorts of people telling me all sorts of bullshit.

Anyway, instead of concentrating on one product and trying to generate some money through sales – lemonade-stand-like – I was spending everything I could come up with making prototypes and plans. I had trouble finding a leatherworker, so I ended up trying my own hand at it. I found a shoemaker who gave me a lot of good advice and information, like where to get tools and leather, and some basic do's and don'ts. The government money I applied for never came though – it turns out the guy in charge of my file quit his job and nobody took it over! – and I was eventually left penniless, starving and owning all this random stuff, like leather tools.

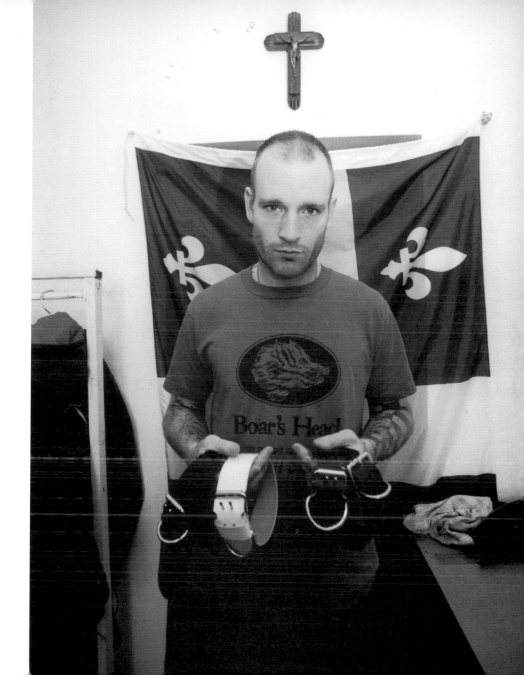

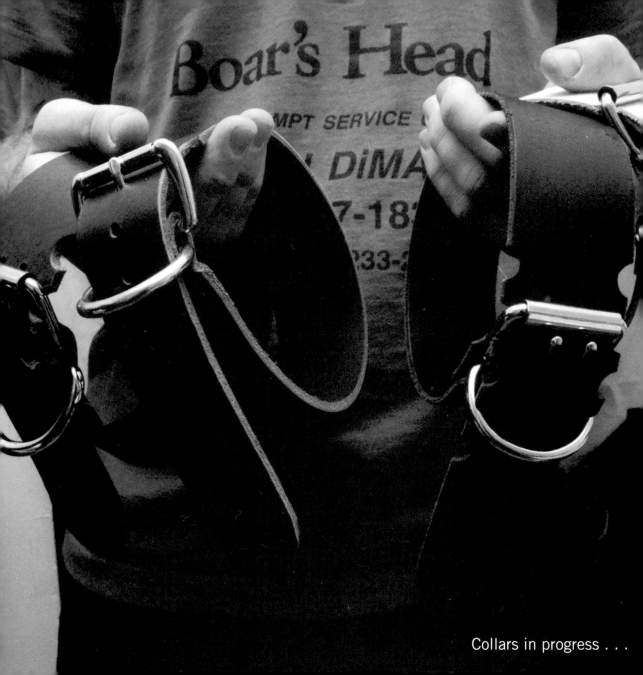

Collars in progress . . .

I did what I should've from the start; I climbed out of that hole, one collar at a time, until my name started getting around and the right kind of people started coming to see me.

What's your client base like?

Well, that's what I was just getting to. I started off making collars for my own dogs. My partner at the time – he fucked off on me over some unrelated bullshit and is hopefully shitting himself as he reads this – he and I used to walk up and down St. Catherine's [main shopping street in Montreal] with matching pit bulls wearing matching spiked collars. It was a little advanced for back then. People weren't used to seeing pits around like they are now. Nowadays, little kids run up to me and are, like, "Red Nose?" Anyway, me and this guy would stroll around and give out our digits to people who asked about the gear. And people always noticed the gear! There was no overlooking these three-inch wide, spiked-out beasts we passed off as collars! I remember our first customer: this strip-club barker named Boris . . .

Anyway, that's how I started out. All word-of-mouth. Totally random. Thing is, you never know who people are gonna talk to. I had a $30 cat collar bring me a pair of $200 Bull Mastiff jobs! Eventually, word got around and I was able to start making the kind of stuff I wanted to be making: crazy, high-end next shit that blows people's minds!

How do you balance function and fashion? Is that even a concern?

Function is very important to me. A thing's gotta work – and last – for it to be appreciated by its owner and, almost as importantly, to be seen by others. My collars search for the line between elegance and function. A collar needs to be tough and beautiful.

I think it's also my Scottish side coming through. It's got to be practical! It's got to "kill two birds with one stone"; look good and work . . .

Craziest stuff you've had to make?

In terms of dog collars? I've made all sorts of crazy collars: collars with handles; collars with secret compartments for drugs; collars with locks on them; crazy-spiked collars for Chihuahuas; green collars with shamrock patterns made just for St. Paddy's Day; collars made to match [Nike] AF1s . . .

What does the average person wanna spend? What do most people ask for?

It's kinda hard to pin down, really. A lot of people just want a basic, well-made collar. Durable. Elegant. Personalized, maybe. They'll spend anywhere from $50 or $60 for toy dogs, to $200 for giant breeds. That's including a matching leash. Others will spend upwards of $500 for an entire set of gear, including a top-of-the-line collar, two different-sized leashes and a walking harness.

A lot of people have special needs that only a guy like me can fill. You see, it's more

of a service that I provide than a product. I sell what stores don't have. What only *you* can imagine! It's really about being able to get whatever you want . . .

Would you say the majority of your business is bulldogs?

Lately? Yes, actually. Mostly because my own dog generates a lot of attention from pit lovers and the whole word-of-mouth thing happens. Also, I guess pit owners understand the importance of durable gear.

Why did you get a pit bull? Where is it from?

I had been thinking about getting a dog for a while. This was six years ago; when I was just finally starting to feel able to care for one over an extended period of time, when a friend mentioned he had met someone selling pit bulls.

My first experience with pits had been a positive, if somewhat awe-inspiring one. When I was about ten, there was this middle-aged man who had one up the street from me. This guy was tall, black and always well dressed. His dog, a tiny, red-as-hell female, was robotic! This one time, my friends and I saw her sit motionless for half an hour while he went back inside his house to get something he had forgotten. She would jump the baseball field fence on command, differentiating between going "over" it and going "around" it, where she would trek all the way down the field and come back on the other side! Anyway, I bought Java for next to nothing off of this charming thug – and she turned out beautiful!

How did it affect your life?

Like I said, at the time, I felt pretty steady for the first time in a while. I had traveled a

bit when I was younger, hitchhiking as far as San Francisco before ending up living on the streets in Vancouver. Anyway, I had a steady girlfriend and job and stuff – I was a bike messenger – so I went ahead and got her. Over the years, though, Java has taken care of me more than I have taken care of her. She reminds me to eat, drink lots of water, get lots of exercise and sleep. She keeps me off of the streets, really. There were definitely moments when I would've said, "fuck it!" and gone back to Vancouver or California or god knows where, if it hadn't been for my responsibility to Java.

*** **JONATHAN IS ANOTHER SHINING EXAMPLE OF A GREAT DOG OWNER.**

TALKING WITH
DIANE JESSUP

Diane Jessup is a pit bull expert and one of the breed's most outspoken champions. She has written three books about pit bulls: A work of fiction called *The Dog Who Spoke With Gods*, co-wrote/ghost wrote *The Colby Book*, and *The Working Pit Bull*, which she describes as having been a direct response to Richard Stratton's books. Stratton's were the only books on the breed available at that time, and Jessup often found herself trying to defend the breed against people who use these books to justify banning pit bulls. An animal control officer for the past nineteen years, it's safe to say that this amazing woman has dedicated her life to the breed and to the promotion of responsible dog ownership. On the side, she operates a magazine called *Fully Bully*, which she describes as her quarterly continuation of *The Working Pit Bull*.

The following interview took place via email in the summer of 2004.

You are often asked to testify in court on dog behavior.

I did in the past. I no longer do expert work or travel to do workshops. It just isn't fun without Dread [her late dog]; he really was my business partner. It was never the same without him, and finally I just stopped. It wasn't fun anymore. For ten years there, we really got around. We did hundreds of workshops for police, animal control, utilities companies – you name it. It was a great time.

Your dogs compete in weight pull and schutzhund?

Well, I sure try. These past four or five years have been incredibly frustrating for me. Not only have I not been able to compete like I want to, but I've been sitting on probably the best, or at least the second best, competition dog I'll ever snap a lead on. I have a funky form of arthritis and getting around is tough. Then I had to get two knee replacements. I'm getting the second one in a couple weeks. All the time I was waiting to get them, and then the year in between, I just haven't been able to train. It's taken all my years of experience to not really get down about it. Being a cancer survivor helps; I just say, "Hey, dog training is fun, but it is just dog training. . . . It's not that big a deal." But it is smart to sit back and watch a great dog getting older and losing his teeth.

I enjoy weight pull, but I am VERY upset with the way it is going. As more and more ADBA (American Dog Breeders Association) people come over to the IWPA (International Weight Pull Association), the rules that were in place to protect the dogs are going to be removed. You watch. You have these complete morons pulling six- to twelve-month-old puppies, I mean, pulling heavy weight. Even competing with them! This is the rankest sign of ignorance I can think of. Even twelve months, which the IWPA allows, is young for competition. And I bet the pull-on-command rule will fall soon. Nobody in pit bulls wants to train their dogs. It's a damn shame. So, I'm not sure how much longer I'll be in that. I won't stand around and watch nine-month-old puppies pull – that is just plain cruelty and stupidity, and would not make for a nice weekend sport for me. That is why I stay away from ADBA; who needs to go be depressed by what you see on the weekend? I see enough cruelty all week at work as an animal control officer!

I really enjoy schutzhund, but the clubs around here are, well, challenging to go to. Pretty much the same thing. I'm not into watching folks jerk, shock, smack and whip their dogs. I'd love to go to a schutzhund club where people trained using positive methods, but that won't happen around here. Right now I have to drive two hours one way to get to schutzhund or ring training. That's tough. That means half of my weekend is spent messing with one out of twelve dogs. That doesn't seem fair to me.

I REALLY love ring sport. What an incredible sport that is. Really tough. But again, I won't go to a club where I have to watch dog abuse, and I'm not crazy about driving four hours each Sunday. Not to mention, to train with positive methods, I would need to work my dog several times a week. I can't do that without a decoy. So, I guess for a bit I won't be too active. Until I find some young kid who wants to learn for-real dog training. I can only hope!

I have enjoyed my time in dog sport. I've earned a little bit of everything. I got sheep and duck herding titles (with placements!) on old Dread, I've gotten tracking titles, all of them (at least all the ones available back then) and Schutzhund III, etc. I never did get a UD. May try that someday. I can't with Dirk as he can't get ILP'd (he's not neutered). Maybe I'll try with Guppy the Puppy, my only young dog.

You run *Fully Bully* Magazine.

Yup. I'm proud of it! I LOVE to write, but despite all the pleas to do a sequel to *The Dog Who Spoke With Gods*, I'm not up to that. A sequel is very hard to do, I guess, as you just want to tell the same story over again. I tried it, and that is what my agent told me; and she was right. You know, what I really, really wish if I was good enough to write, would be a novel about what the United States of America would be like if it had been founded by Pagans instead of Christians. I'm fascinated by that. (I'm a Pagan.) I think that would be a blast. But my agent says, "Write about dogs!"

Fully Bully Magazine is a labor of love. It only makes twenty cents a copy, and I use that money to send copies to those who won't buy it but NEED to get it! Like PETA, *Animal People* Magazine staff, HSUS, etc.

Break down your average day for me.

That would be hard to do. Would you want the old Diane, who used to train dogs? Or the crippled Diane, awaiting surgery?

I guess I wake up in a bed with usually about five to six dogs. Two to three pit bulls and three terriers. When I open my back door, believe me, the neighbors all get up! The dogs SCREAM out the door, terriers hooked to the hind legs of the pit bulls. I'm definitely not one of those "make them sit before they go out the door" freaks. Hey, it's morning; they're happy, wound up. Go greet the world "pit-bull style", I say!

I take dogs to work with me. From one to four dogs. Work? I consider it nine hours a day I can't account for. My life is not at work; it's frustrating and sad. I don't work with "dog people" (except for one kid), so that makes it more frustrating. Animal control work takes tough people. But you know what cracks me up the most? People who walk in and dump their dog, or their litter of kittens, and dare to say to me: "I couldn't work here . . . I couldn't do what you do." You know what I tell them? "I COULDN'T DO WHAT YOU DO!" I'm lucky that our property at work has wonderful trails through the woods. What a stress release to walk there with your dogs!

So, back from work. From the minute I get home till I drop in bed, it's dogs! I don't have a "life". I don't date. I don't have time for any "people"! We springpole and treadmill (in the winter) and play ball, and train (somedays) and work in the yard, and just have a ball. It's what I live for. The dogs are just great. I also have some turkeys, which are awesome pets as well.

Go in the house, and I may do a bit on the magazine. Then fall into bed with the dogs. That's it. I haven't been to a movie in probably fifteen years!

I think it would be safe to say that you've dedicated your life to this breed of dog.

Yeah. And to the fight for proper, common sense care of dogs.

How did you come to own pit bulls?

I grew up around the guard dog industry. It was my complete passion. I only liked Dobes, but when I saw my first pit bull, it was an immediate, "OHMYGAWD". It was a tiny game bred bitch out of Texas, and she was as happy as she could be, but boy, she would bite! But she was friendly! I wasn't aware that a dog could be friendly and confident, and still be tough.

I was used to the wary, suspicious Dobermans. I was taken instantly. I quickly understood that the pit bull was different from the Dobe and other Germanic guardian breeds, and realized that the English personality of the pit bull much better fitted my personality. (I think that was bad English right there!)

I looked at some pit bulls, but they were all UKC show bred stuff. Deadheads. Then I ran into this drug dealer selling "game bred" dogs and, well, that's a long story, but I ended up with the pick of the litter . . .

How many do you own presently?

I have Dirk, then old Grip and Grip's kids: Fletcher, Butchie, Mhorgana, Erin Fay and Pagan. And I just added Guppy the Puppy. She's about seven months now. She's growing up wild, as I can't do a thing with her right now.

Do they all compete?

Well, all of them have titles, except Gup. She will, but not for a while. Dirk is titled in French Ring, and Grip has a Schutzhund I, and just missed her French Ring Brevet due to my stupid handler error. She is retired now, at eleven. Grip was also Silver Medalist in the IWPA Region 2 – the one and only year she pulled. She was poisoned in the middle of the season and had to stop cold for a month, but she came back gamely and I was very proud of her. She only pulled that one season, as she wasn't really into it.

Her pups all earned Working Dog Superior titles in weight pull (except Pagan, who only earned a WD). That is about all they are good for. I learned a lot about that line of dog a little too late. I gave away the good pups and kept the rejects! They are six years old now. As sorry a bunch of dogs as you ever saw, but built well, pretty and very willing to try. I COULD title them in schutzhund, but I don't because I know it would be a lie. They would be "built" dogs. I got no reason to do that. They know who they are, I know who they are: they are pets. That's just fine with us. I got me a competition dog: Dirk. All I gotta do is get my legs back under me.

From what I read, Dread was a very accomplished dog. Tell me about him. What made him special?

Dread was special. Absolutely. I'll never have another friend on this earth like him, human or dog. We shared a soul. I knew everything he thought, and I believe he knew everything I thought. Why does that happen? I don't know. That was the basis for writing *The Dog Who Spoke With Gods*. . . . How do these really strong friendships form? It's interesting.

I'll be honest; Dirk has a FAR better temperament than Dread. Dread would kill someone if I'd asked him to. Dirk would have to have a good reason. Dirk LOVES people. Dread loved me. His temperament was not correct for a pit bull, but I was smart enough to be able to keep him out of trouble. But would I want another dog like that? No. Not really.

I'd give all my tomorrows for just one yesterday where Dread is concerned.

But I don't want another man-biter. Nope.

To be sure, Dread never bit anyone. He was a professional. Smart as hell. He wasn't stupid. And he wasn't unsound; he was just too defensive. You couldn't reach in the car with him if you didn't know him. That, to me, is not correct pit bull temperament, and in the hands of foolish people, it's getting the breed in trouble.

Yeah, old Dread was smart. I loved that dog more than I loved anyone other than my parents. Period. When we did movie work, the movie people were always amazed at how I handled Dread. There was no leash and collar. No shock collar! I'd explain things to

him. One time we were doing *Simon and Simon*. Dread was supposed to be a Seattle Police Dog (!). I took him and the actor aside, and sat down. I showed Dread how he was supposed to run in and grab the guy's leg. The actor was like, "whoa!" Dread had to run down a dock, then into a darkened tent because we had lost the dark and the sun had come up. With all that, Dread understood, after I showed him where the padding was UNDER the pants, that that is where he was to bite. Only there. Dread did not want to hurt people. That is why I call him a professional. He just knew it wasn't real. I could go on and on about his movie work. It was amazing.

What does "game" mean to you, and why is it so important to keep breeding for it? And what's the best way for the average dog owner to see it?

Game to me means one thing: a dog that is tough, and that tries hard at whatever it is good at. A sled dog can be game; it has to be to finish the Iditarod [Alaskan dogsled race]. A pointer can be game if it can finish a three-hour hunt at full speed in the killer heat. A pit bull can be game if it engages a large animal like a bull and tries to overpower it. We can test for gameness in ANY breed by means that are cruel or illegal, or we can test in ways that are meaningful and legal. It is up to the breeder which way they choose.

I have never seen where a dog's being a pit champion guarantees that it's game. Perhaps you've seen all the comments in *Sporting Dog Journal* about how so-and-so's dog won but it was a cur, or a cur later, etc. My point is, I could throw Dirk in with three pit bulls that were cur, and he would be a champion. Do it five times, he is a Grand Champion. What have I proven? That he can beat up another dog. A dog who may have heartworm, be dysplastic, be a cur, or be sick and worn down from a poor keep.

Richard Stratton makes the comment that he absolutely can't tell if a dog is game or not unless he fights it. I find that ridiculous. Anybody with dog sense, who lives with an animal closely, gets to know that animal's personality. IF THEY ARE HONEST (with themselves), they come to know what that dog is about. But you must be a real "dog person". You MUST understand what you are seeing. And you MUST be looking for the weaknesses – not the strengths – in a dog. Too many people constantly try and make excuses for a dog, or see stuff that isn't there. I guess all my years in police/schutzhund/ guard training taught me one thing: don't kid yourself about what your dog is or is not. It gets you nowhere.

I bet you I could go down the row of my dogs and tell you exactly what each one would do in a dogfight. Why? Because I know them and I'm honest. I know which ones would secretly like to throw in the towel, and they're often the "most aggressive" ones. A lot of people are going to laugh at these statements, but then again, how often do these so-called "dogmen" put a dog in the pit they thought was "The Bomb" just to have it cur out in twenty minutes? Maybe I could have told them that and saved them a bunch of money or crack.

As to the "average" dog owner? First, they don't NEED a game dog. It would be nice, but it's not necessary. And HOW game a dog do they need? Dead game in a dogfight? Why? Are they going to fight it?

To me, a dog that can handle screaming, yelling kids is game! Does the dog try hard to please? Does it try hard to do what is asked of it?

But for those casual owners who really want to try and either see what they have or preserve the true bulldog attitude, I think there are things – legal things – that can help you make a determination. For instance:

a) I don't think much of a bulldog who won't work a springpole. Doesn't mean it isn't a nice dog – I have a couple here that won't – but a BULLDOG is known for its ability to grip and hang. I define the breed by that. And so have hundreds of generations of my ancestors.

b) Is the dog a deadhead? I think a "game" dog is keen, active, wanting to work. There are exceptions: some dogfight winners have been very lazy. But old man Colby said a dog who will quit in his work will quit in a fight, and I tend to agree with that.

c) Do you have to be careful to keep the dog from hurting itself in the work? On a hot day, will the dog try and run itself to exhaustion? If you put the dog's ball up on something, will the dog almost kill itself to get it?

I think these are some of the things a person should look at when they are making a determination if their dog fits the picture of a correct or "game" bulldog.

If we bred pit bulls that weren't game, would they still be pit bulls?

Almost every breed has faced the issue of purpose bred versus show bred. My favorite example is the English Setter. No breed on earth shows more clearly the difference between show bred and working bred. Field English Setters are small, wiry, hardly any coat to look at. And they are BIRDY! They can run a three-hour heat at the championships. They're tough. A show-bred English is huge, slobbery, with a sleepy, stupid look.

His long, flowing coat would quickly become tangled and ruined in brush. They are so big, they have no wind; they have no drive. They are not birdy.

The same thing is happening RIGHT NOW in pit bulls. I consider the Am Staff a different breed after forty years, so I will discuss the pit bull here. Right now, you can go to certain yards and find correct bulldogs. I will be honest and say that most of these yards are persons who breed "game dogs", whether for fighting or just profit. These are the forty- to sixty-five-pound dogs, nothing special to look at: fawn, buckskin, brindle, black. On the other hand, you have the UKC show dogs, what I call the "California" look; the big, eighty-pounders, awful lot of them are red noses or blue, and they don't have enough wind to blow a napkin off the table. They might be good weight pullers but weight pulling does not test wind.

Now we have the straight-up puppy millers selling "low riders", and dogs bred to be so heavy and wide and unsound that they're laughable (if it wasn't so sad!). You take one of these dogs and put it in the arena with a wild bull, and you might as well put an English show bulldog, or an "Olde Bulldogge", or some sort of ludicrous dog in there. They can't dodge, they have no wind, they have bad hips . . .

I don't worry about the future of the breed. I'm old enough to remember when this happened to the Doberman. Dobes went all the way to number one in popularity with the AKC. The average lifespan of a Doberman at that time was four years, due to health problems. But today, if you know where to look, you can still find a good Dobe. It's tough; and the dogs are still reeling from the health issues popularity brought to them, but the good dogs are still there with the serious people.

I think there will always be those who truly understand what a bulldog is, and keep it pure. After all, this breed has been around a very long time, and if you look at the engravings, it hasn't changed much. The correct form seems to be the one that survives.

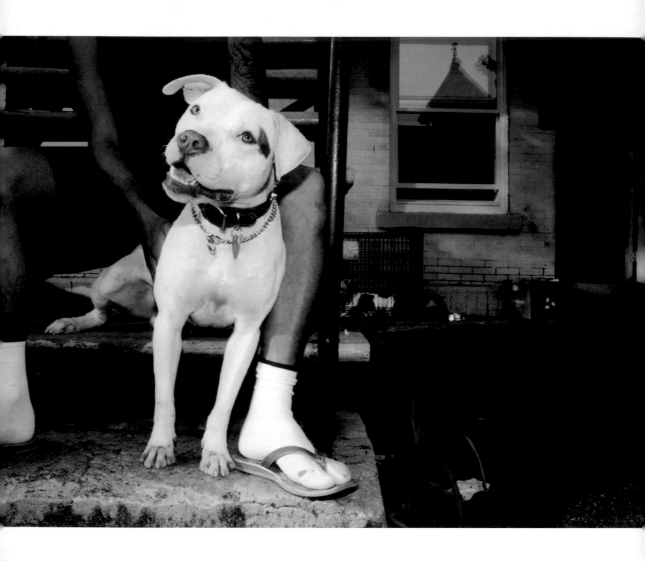

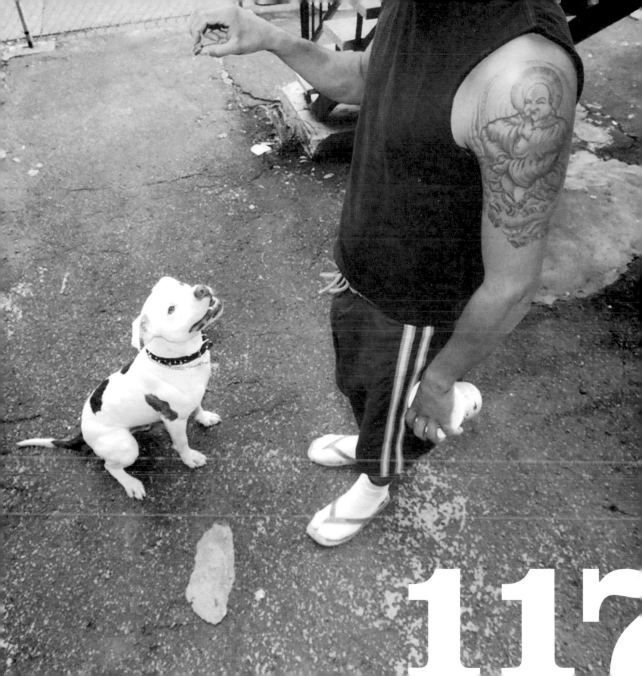

So what do you guys have in stores now?

Currently we are featuring the Fall 2003/Winter 2004 clothing line. Over the next year, we will focus on building the brand name through expanding our clothing line into a household name among dog owners, with plans to go into other pet areas from there. In late 2004/early 2005, we will launch our line of accessories, toys, dog food, etc . . .

What's up with hats, though? Are they in the works?

Right now we have bandanas with matching leg/thigh bands. Four to six months down the line, we will feature visors, paint style caps, scarves and winter hats. We are aiming for end of winter for winter hats. If not, we'll hold out until next winter and just do the spring wear.

How about formal wear for when we step out?

Not at the moment. We are focusing on a more broad customer base. We do customized pieces for our upscale clients. We can be contacted through our website at Boomer129.com.

What kind of accessories will there be?

Hats, bandanas with matching leg and thigh bands, some dog jewelry, although we are looking into the possible liabilities: choking, swallowing and such.

INVESTIGATIVE REPORT: Boomer129
January 23rd, 2004

I had heard DMX was making dog clothes. The company is named after DMX's dead pit bull Boomer. (My guess is that they at one point lived on 129th Street?) Dog clothes have functionality in certain climates. I started emailing around to find out who was behind all of this. I found Eric.

Do you have a fashion background?

No, finance and sales.

Who is designing the gear?

The line is designed by myself and Tony Sorbara, a fashion industry veteran with twenty-plus years' experience. He has worked with many top-name designers and companies, from Burberry to Oscar de la Renta. DMX has a say in what the final product is as well.

Can pieces be worn together or just one at a time?

Garments can be used just like clothing for people. We try to follow many trends of today. We have team colors, matching outfits, etc. . . . Care will be the same; most things are machine washable, with some requiring special care, i.e. dry cleaning.

What kind of money are we talking?

Prices will range from $24.99 to $199.99.

Are you making gender specific gear?

Right now everything is unisex but we will have gender specific items in the future as the company grows and sees demand.

So do dogs like being dressed?

It depends on the dog. Dogs are like people: each with their own personality and tastes. Most dogs don't mind when it's for a particular reason, like a raincoat for when it's raining or a sweater if it's extremely cold and snowy – especially short-haired dogs.

Are there bike guards, leash loops, etc.?

There are a few leash loops, but most items are designed in such a way that the clothing won't run into any interference with the dog's collars or leashes while being walked. We do have special features like cell phone pockets, key rings, wallet holders, and a few to name later. Collars on the clothing are shorter on some garments. Hoods can be pushed behind or under the dog collar, etc. . . .

So what do you guys have in the works?

Specific items. I don't want to give too much away. We're still the new boy on the block! We're going to make faux-fur bomber jackets, brown faux-fur collars (fur inside, leather vinyl outside), matching pattern for lining. Also, real fur and real leather for the upscale market.

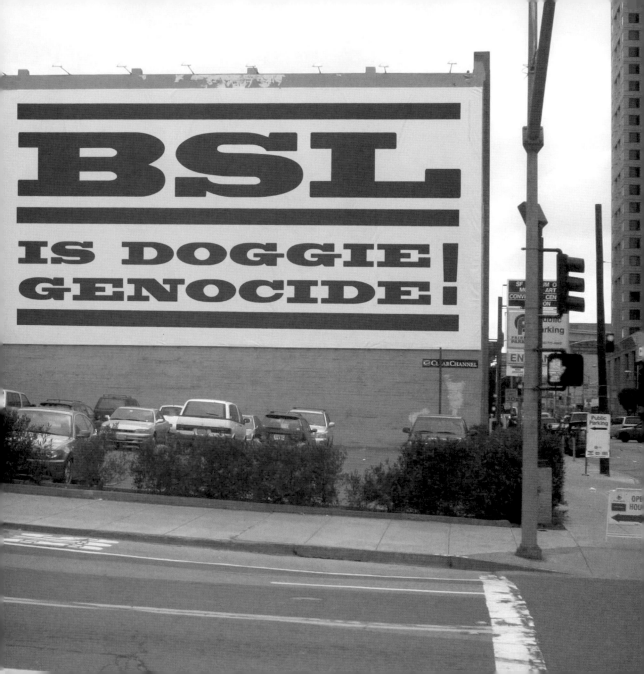

BSL stands for Breed Specific Legislation. You will hear a lot of talk about this in your local news whenever there is an incident involving a specific breed of dog in your area. In a nutshell, BSL is doggie genocide. Blaming a whole race of dogs for the actions of a few is no different than saying all people of a certain race or ethnicity are bad because of the conduct of a tiny proportion of its members. It's just that in this case, we can't ban people (at least not anymore anyway).

The powers that be don't actually care about breed bans. They just want re-election. They will only really act on what the majority wants them to. It's all a high school popularity contest for them. In fact, most of the time the politicians can't even pick a bulldog out of a line-up of dogs (ask Ontario Attorney-General and Bully breed ban advocate Michael Bryant about that one).

Fighting the BSL.

1. As annoying as it is to speak to people on a routine trot with your dog, take the time every once in a while to let a kid pet the dog as you field questions from his or her anxious parent. Prevention Through Education. When the lawmakers start the witch-hunt, you will have a few more people on your side.

2. The moment the BSL talk starts, get a petition going. If you can't write one, get online and steal one that has already been written. Change the particulars so that it makes sense for what's going on in your area.

3. Get good press. Media attention always helps. Are there any stand-up dogs or owners in the area? Any pro-bulldog expert witness-types around? Any remarkable dogs nationally? Get a little kit together that you can give to the journalists before they get on the lockjaw bandwagon.

4. Get your "By Any Means Necessary" on. Protest. Get a peaceful demonstration together. Get people out. Let 'em know you're not having it. Chain yourself to something. Make signs.

Picket. Come up with a chant for the demonstration, something catchy like, "THE DEED, NOT THE BREED". Get people together.

5. Buy Karen Delise's *Fatal Dog Attacks: The Stories Behind the Statistics* (available at www.fataldogattacks.com) and Diane Jessup's *The Working Pit Bull* (available at www. workingpitbull.com). Read them and then make sure that the lawmakers in your area have read them as well. Highlight the good stuff before you give it to them. Make sure they know the truth behind the numbers.

6. Don't just sit there. If you think someone else is going to fight the BSL battle for you and that the problem will just go away, you will soon find yourself dogless.

7. Be part of the solution. Help come up with breed ban alternatives, like a dangerous dog act. Suggest making the owner responsible for the dog's actions. Penalties could include heavy fines or prison time for anyone with an out-of-control dog. This, I can guarantee, will show results. Hell, even having to muzzle your dog in public is better than having no dog at all.

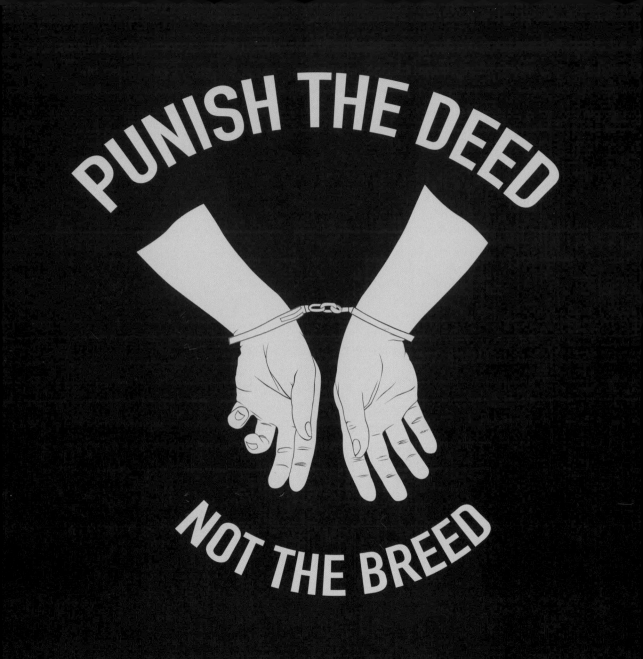

Turf was born Jean Labourdette and grew up in Malakoff, a suburb of Paris. He is in his late twenties.

Turf makes art for a living. It started with graffiti but depending on the day, you can catch him doing design, illustration or canvas work. Lately, his focus has been a documentary film about people who paint in the Catacombs below Paris.

When I think artist, I think sissy. Turf is not a sissy though. Well, he *is* all into the alternative medicines, *Reiki* and finding his inner self. In short, the boy is a step away from hugging a tree.

The following interview is combined with some of his work and photos of his life with the dogs. Turf is another fine example of a pet bull and nanny dog owner.

How did getting the dogs affect your life?

If anything, it made me more of a responsible human being, and grow as a person. I mean, even if at times I wasn't doing the best things for myself, I had to make sure I was strong for the dogs. When you have in your hands the life of a being that gives you its complete trust, that loves you and is one-hundred percent faithful, and would give its life to you without hesitation, you have a responsibility. It changes the factors balancing your life.

I first got Jay in 1994. I think, most importantly, that he taught me how to love each day, whether I wanted to or not.

Afterwards, I got Lula, in '97. I wanted Jay to have a companion. That's the main reason I got her. From then on, it was twice the amount of work and responsibility. And to top it all off, this was during the period in France when the anti-pit bull laws were becoming increasingly enforced.

There's also the fact that having these dogs put me at the center of these polemics, these injustices. Being the owner of dogs that have been unjustly considered monsters and permanently culpable has made me realize to what extent the media and the politicians can manipulate public opinion and create controversy. So, on one hand, many good things have happened in my life as a result of having these dogs. They have taught me and given me so much, but I have also harbored an enormous amount of stress and anger as a result of a general atmosphere of stupid judgment and injustice . . .

Why a pit and a Staffy? How and why did you choose these two dogs?

I wanted a Boxer, but in, like, '92 or '93, I met a guy with two Staffies, and I fell in love with the breed. I lived in Paris at the time. With no car and a super-small apartment, a Staffy seemed like the best option . . . all the characteristics of a big dog – strong, high energy, big personality – but all in a small package. It was the ideal choice. The dog was small enough to travel anywhere with me without restriction – public transit, restaurants, etc. Later on, a friend of mine who had a super gentle and intelligent pit, that I loved, had puppies. I saw them six hours after they were born. When they were only a few days old, I already knew which one would be my bitch.

For a period of time, the dogs appeared in your art . . . a lot. How did that come about?

Well, they were with me all the time, everywhere I went. They were my real crew. So when you create, you're often inspired by what's around you. And the dogs were always around me. So it's not surprising to me that they show up in my paintings and comic strips. Those dogs were with me everywhere: restaurants, the subway, clubs, abandoned buildings. If one of my friends invited me over, the dogs came. We were a package deal. We even vacationed together. It was twenty-four-seven, three-sixty-five.

Most memorable moments?

I don't remember moments. All the time we spent together was great. When I think of them, I can only tell you what I feel in my heart. They were like brothers and my kids all at once. I remember funny things that happened. Like, when my Staffy, Jay, decided he was going to make love to my unsuspecting girlfriend's face. But none of these stories could completely explain who my dogs are and what they are like.

Good and bad times?

Good times? Every second we spent together; every walk, every squeeze. Anytime spent together was priceless to me. As for bad times? Yeah. In their puppy stages I would come home to my apartment in shambles. I had to line the apartment walls with plywood and cover up all the electrical outlets. I've had my best CDs eaten by my bitch. And to this day I don't know how she got in to certain stuff. One day my mom was walking my bitch Lula. While she was relieving herself, audiotape ribbon started coming out of her ass. My mom had to pull the ninety minutes worth of cassette out of my dog's rectum. Another time I came home really late and Jay, who was bored, had been gnawing for hours on his plastic basket that was supposedly "indestructible". That gave him diarrhea at six in the morning just at the head of my bed, above my pillow, all over the walls. Continuing in the chapter of unwholesome stories, there are all the times I had to kick dogs that were coming to attack my dogs. I had to deal with cops too, because they always wanted me to have a muzzle and a leash on them at all times. I also had to deal

My mom had to
pull the ninety ~~minds~~
minutes worth of
cassette out of my
dog's rectum

with those idiots that want to test their combat dogs on your dogs. Or those who thought it would be a good idea to steal your dog from you.

So there it is. Having radar in your head at all times . . . so much pressure. At one point I started carrying pepper spray, in case anything happened to my dogs. Then there was a period where I walked around with a pistol that shot rubber bullets, whenever I brought the dogs to the forest near my place! Not such a healthy state of mind, you know? But the thought of anyone trying to hurt or steal my dogs was a little overwhelming for me.

Best thing about owning these dogs?

Absolute and unconditional love, and loyalty without fail. For life.

What's up with your mom?

Since I left France, my mom has been taking care of my dogs. It's pretty hard for me not having them around, but they are happier over there in the mountains far from me than here with me in the life I am living right now. If I brought them over now, it would be selfish of me. That said, I try and return to see them as much as possible. They are my family. And if life allows it, I may have the chance to take care of them full-time again soon. But they love my mother as much as she loves them. Which is funny, because she was someone who was afraid of dogs and was not at all into it when I decided to get a dog so similar to a pit. Today, she is the happy owner of two pit bulls, in a mountain village of our beloved France (of very fascist and stagnant ideas regarding dogs). Today, she explains to people – those who wish to keep an open mind – that a pit is just another kind of dog, and not a kind of hybrid, bloodthirsty monster. A dog is its own being, and like any being, the context in which it lives and its education play a primordial role in its psychological well-being – which will ultimately determine its character.

144

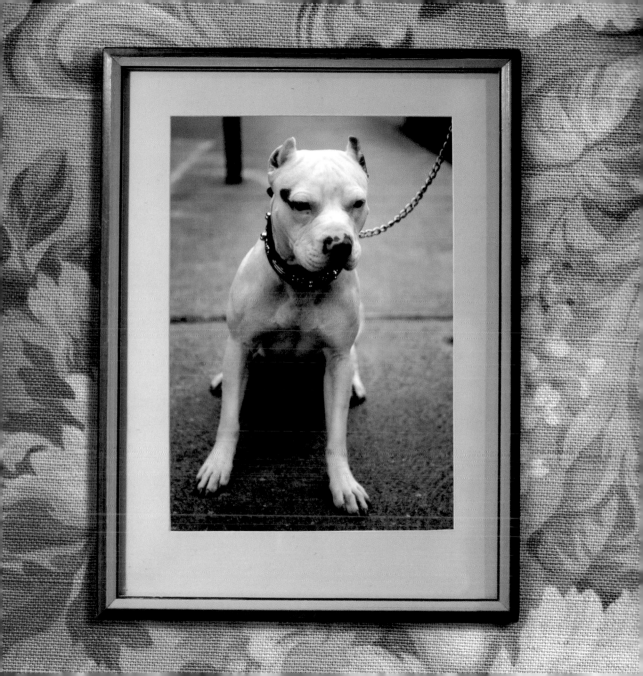

Theatre of the Absurd or: Why I learned to stop worrying and love the pit bull

Matt Ferguson

"Pit Bull" seems to be a key word in the media that generates a firestorm of bad publicity nearly every time it is used. So much so that a recent Google news search turned up 1,180 hits, including a story about a fatal pit bull mauling in Brazil. This bad publicity usually provokes calls for bans, putting pit bulls in the crosshairs of breed specific legislation (BSL).

Pit bulls are indeed responsible for more fatal attacks on humans than any other breed of dog. Yet according to goodpooch.com, a website which promotes responsible dog ownership, "the overwhelming majority of 'pit bulls' never bite anyone."

In a similar vein, Dr. Richard Polsky, an animal behaviorist who runs dogexpert.com, writes, "The list of breeds most involved in both bite injuries and fatalities changes from year to year and from one area of the country to another, depending on the popularity of the breed."

According to the American Canine Foundation (ACF), there are about 200 cities and towns throughout the United States with breed specific legislation in effect. Reasons to ban pit bulls abound in newspapers, magazines and television reports. The public is consistently barraged with stories about a pit bull's

lockjaw, biting power, natural aggression and unique brain chemistry. But thanks to the Internet, it is possible to navigate through the "bullshit" and dispel the myths that surround these dogs.

The media often reports that pit bulls have a jaw locking mechanism. But a quick Google search will reveal this to be very much a myth. According to Dr. Lehr Brisbir, an animal behaviorist writing for the ACF's website, "there is no evidence for the existence of any kind of 'locking mechanism' unique to the structure of the jaws and/or teeth of pit bulls." In other words, lockjaw is an early sign of tetanus in humans, not what occurs when a pit bull sinks its teeth into an object.

We are also told that pit bulls are, in the words of Ontario Attorney-General Michael Bryant, "inherently dangerous". Yet according to the American Temperament Test Society, pit bulls actually score higher in temperament tests than Beagles, Schnauzers and Golden retrievers. Karen Delise, author of *Fatal Dog Attacks: The Stories Behind the Statistics*, writes, "no dog is inherently vicious."

Neither is there any brain chemistry unique to pit bulls that makes them more prone to turning on

people. Vivian Singer-Ferris, executive director of the Kerwood Wolf Education Centre writes, "Human and animal-focused aggression in pit bulls is a learned behavior. It is a human problem, not a genetic predisposition of the breed. Genetically, in fact, pit bulls are indistinguishable from other dogs." To be sure, there are little to no objective standards by which we can measure a dog breed's inherent danger index.

With all the media sensationalization, it is little wonder that so many people are afraid of these dogs. But in truth, cigarettes are statistically far more dangerous and deadly than pit bulls. So are bicycles. For their part, governments are of little help, as media storms often give them the opportunity to harness the energy and use it to their advantage when it is in their interest to do so.

The government of Ontario is a prime example. It hopes to make Ontario the first state or province in North America to ban pit bulls. So far, the move has been nothing short of a theatre of the absurd, with a case based on gross exaggerations and misrepresentations.

At the initial press conference, Attorney-General Bryant spoke of "150-pound" beasts (in reality, these dogs weigh up to 80 pounds [36kg]), described them as "ticking time bombs" and "dangerous weapons", and consoled a distraught mother of an attack victim. He based the government's case for specifically targeting pit bulls on two high-profile attacks at the time, the second of which, it was later learned, did not even involve a pit bull.

Ontario's Bill 132, the proposed pit bull ban, refers not only to recognized pit bull breeds, but also any class of dog that looks like a pit bull. It also gives police officers the power to seize a dog, in some cases without a warrant, if he believes on reasonable grounds that the dog in question is a pit bull. According to Goodpooch, even trained experts have trouble distinguishing a pit bull from another breed. How then are police officers and concerned citizens expected to? There appears to be no protection for other dog owners who may see their pooches seized in a case of mistaken identity.

The Ontario experience illustrates why BSL is an ill-conceived plan that does little to address the source of the problem. It has been called a "band-aid" solution, as it does little to protect the public from dangerous dog attacks. Instead of reinforcing dog owner liability and instituting stiffer penalties, it paints responsible dog owners with the same brush as irresponsible ones.

The goal of the fiasco seems to have been to confirm the existence of a crisis, perpetuate hysteria and then finally console a jittery public with the promise of action. But hysteria that has consumed a majority does not make it any less irrational. And it certainly does not legitimize rights-stripping legislation that fundamentally lacks perspective. Governments have the power to manipulate public opinion and manufacture consent through the media. And because pit bull owners make up such a small minority of the population, it is very easy for the government to exaggerate the threat and take advantage of majority apathy or ignorance in shaping the public's perceptions of these dogs.

Rights, in this case property rights, never come into question until they are threatened. But because this threat only affects a small minority of the population, it is very easy for the majority to excuse or ignore, no matter how exaggerated it is, especially when they have been told that it is for the common good.

BSL in towns and cities across North America has seen mixed results; certainly there is a drop in attacks by the targeted breed, but this is generally accompanied by a rise in dog bites and attacks among other breeds. Groups such as the ACF, the Humane Society of the United States and the United Kennel Club have come out against BSL. The Canada Safety Council has stated that "breed bans may provoke people who want aggressive dogs to seek out other breeds and breed or train them to become vicious."

Breed specific bans are bad for all dog owners, for there are no absolute measures that allow us to assess a dog breed's inherent danger. Therefore, if we accept the notion that there are domesticated dog breeds that are more "dangerous" than others, the bar for what is said to constitute a dangerous breed becomes lowered each time we ban one. And as we have seen that some governments have no qualms about pursuing a cause that has little to no foundation, how can one be sure that after pit bulls are banned in a particular jurisdiction, other stigmatized dogs such as Rottweilers, German Shepherds and Dobermans won't be next on the "to ban" list? With pit bulls gone, there will be nothing to compare the alleged risk factor of these dogs to.

By banning particular breeds of dogs for the presumed benefit of the common good, the government actually does little to promote the idea of a responsible citizenry. A society that moves to exclude breeds such as the "nanny dog" is a society one step closer to becoming a nanny state.

*** Matt Ferguson was told that his ideals died with John Lennon on at least one occasion ***

Voice 1:
Dogfighting. I won't do it. I don't want to see it. I couldn't handle seeing an animal suffer for any amount of time. It's cruelty to animals.

Voice 1:
What? That's like comparing jaywalking to genocide. It would be funny, if you weren't being serious.

Voice 2:
But objectively, how is it different from the Running of the Bulls in Spain, bullfighting or racing horses? And more importantly, how is it worse than invading a country and wiping out thousands of people, not only soldiers, but also women and babies?

Voice 2:
I'm just saying that it is humans that are bloodthirsty. Dogfighting has been around for hundreds of years, probably longer.

The Voices in My Head.

Voice 4:
You know, that isn't much of a life. In fact, if I were a dog – and these are, of course, just my thoughts – I'm sure I would rather live on a fifteen-foot chain on a dogman's acreage, get conditioned for six weeks and meet my destiny a lot sooner than live in a tiny box in someone's house.

Voice 3:
And that said, to understand the pit bull, one must understand that without dogfighting and the dogman's quest to create the gamest, strongest, fastest dog with a high-pain threshold and great endurance, the bulldog would not be the ideal family companion that it is today. And that, no one can deny.

Voice 1:
eople who starve their dogs, verbally, physically or even emotionally abuse them, or let them live in inhumane conditions or in pain should be put down. Same goes for the puppy millers.

Voice 2:
Exactly.

Voice 1:
While we're on the subject of things I can't handle, I have an equally big problem with people who crate dogs, especially show-type breeders that keep their dogs cooped up all day.

Voice 2:
Atta boy.

INTERVIEW WITH A DOGMAN

How did you get into bulldogs?

Well, I always had a love for dogs, and my first dog was a Doberman. And then, I was on vacation and I bumped into a guy that had a dog, and I thought my Doberman was a fight-crazy dog, and I was completely against this, and I was telling the guy, "Hold your dog back, please, 'cause if my dog gets loose, it's gonna hurt it." And he laughed, and I laughed. And in the end, I found out what a pit bull was.

And how long have you been involved?

With pit bulls? Twenty-five full years.

And why do you love this breed? More than –

Why can't you love this breed? They can do anything any other dog can do, and then eat it . . . you know what I mean? They can do any trick any dog can do. A pit bull called Panda, in the mid '80s, was the first dog to get something like ninety-nine points in Schutzhund training, and it was a pit bull – not a Shepherd, not a Lab, not any other working dog. This woman owned it.

Do you think people that roll dogs, roll dogs for the love of the sport, the love of the dog or for the love of money?

They roll it for all three reasons and even more. People have an ego – one that they feed on – but the truth of the matter is people don't

even know why they roll dogs. They roll dogs just because they got a pit bull. If St. Bernards had the reputation of being fighting dogs, they'd be rolling St. Bernards to say, "I rolled a St. Bernard." A lot of cowards roll dogs, too, 'cause they live vicariously through the dog. I can understand, you know, living through the dog in that sense, but you know, you got to give what the dog gives, too.

What do you think attracts someone to bulldogs?

Oh . . . the status quo of having a tough dog. It's an image thing, you know? Image sells. Look at Nike. Look at all these big conglomerates. Image is everything to them.

Have any of your dogs ever bit a human?

Bit a human? Yes.

Would you breed into a dog that bit a human?

Hey listen, my dogs have never attacked a human. There's a difference between attacking and biting, you understand? You walk over a dog that's sleeping, you step on the dog and you startle the dog, and it will, just out of reflex, turn around and snap at you. That doesn't mean it's "attacking", you understand? That's the difference. I will never breed into a man-biter. Never. A dog that's got tendencies to be a man-biter - never . . .

So are any of your dogs human aggressive, in the least?

None.

So if none of your dogs are human aggressive — and I know for a fact
that none of the "pet bulls" are human aggressive — who owns these
mysterious pit bulls that are biting people, that we hear about on
the news?

The people who breed dogs that bite people, that we here about in
newspapers, have no idea. A guy gets two puppies — gets a male and
female — breeds the female to the male, takes the puppies from that
and breeds them back to the mother. And then, he takes the pup-
pies from that breeding and breeds them back to the mother. It's all
this inbreeding. This makes for a lot of fuck ups. There is no such
thing as bad dogs; there are bad people. Like, "guns don't kill peo-
ple; people kill people." Same thing with the dogs. These dogs, be-
cause the irresponsible owners, the macho guys, think the dogs are
so strong, take them as young dogs, abuse the dogs — not physically,
but they'll tie the dog up to a chain — show no affection to the dog,
leave it in the basement twenty-four hours a day, and when they take
it out, and the dog goes to pull on the chain, they jerk it back real
hard to make it, like, you know, a big macho thing . . . you know
what I mean? They spend no time and share no emotions with the dog.
Because of this, the dog becomes automatically secluded from people
— and wants to eat people.

In your expert opinion, if I wanted my dog to be in peak physical form, what would that entail — diet and exercise-wise — and how long would it take?

Well listen, you can keep a dog in shape all year long depending on where you live and the time you have. The best thing you can do for a dog is keep him in good shape. It keeps him living longer, and a healthy dog is a happy dog. And not only that, you're happy, too, because your dog lives longer. Keeping him fat is no good for his arteries and everything. But, even walking — if you can spend time just walking the darn dog — a good sixty minutes a day would be great, but a lot of people don't have sixty minutes. A good walk and a good diet is the best thing for a dog.

And if I wanted to get a dog in real shape?

In real shape? In real shape for . . . ?

To be in peak physical condition for any kind of dog sporting event.

You need a treadmill . . . but, you don't really need a treadmill. Just walking . . . but walking consists of six hours a day. If you can get a "Jenny", or a treadmill, get the dog running. But what-ever time the dog spends running on the treadmill, you got to double that on walking, so the dog can cool down. You don't just run him on a mill for half an hour, and then put him down; he'll get muscle cramps. You run a dog on a mill for half an hour, you gotta walk him

for an hour — to cool down, come down — and then you massage him once you take him off the mill. You give him a rub down, you know, just like a human that's training, and his muscles ache and everything. But believe me, he'll love it. He might in the first day or second day get nervous on the mill. But once he sees the mill, you can't hold him back; he just flies on and runs.

What are your thoughts on attack-training bulldogs?

I'm completely against it.

Because?

Because they're strong dogs to start off with. They're very loyal in the sense that they'll do just about anything to serve their masters. Now, if the dog is an attack-trained dog and he knows to attack intruders, if the dog attacks somebody, he's going to attack him to his fullest capabilities, and when I say his fullest capabilities, that means he can terminate this guy's life. So this is why you do not have an attack-trained pit bull.

How would you remedy the pit bull problem that you hear about on the news?

I would make sure people did not sell these dogs so openly. People would have to, I don't know, this is stupid you know; "you pass a test; you have a dog." Personally, I don't think every Joe Public

. . . the problem is, all you need is one attack from a pit bull and it's front-page news. It can be fifty other dogs — Shepherds or Dobies — biting people all year long, and it might not even make the paper.

should own a pit bull. This problem, dog bites and everything, did not exist thirty, forty years ago. It started in the late '70s, early '80s, when people and the mass media got hype of this dog called the pit bull — just like I did. But, what happens is, with everything good you know there's always evil that comes out of it. Pit bulls have been around from way back. God knows. There was even that dog in the Little Rascals. Remember Pete the Pup? It was also the United States of America's poster dog during World War I. Every country had one: the French Bulldog, the English Bulldog and then the Americans had a pit bull right in the center of the poster that said something like, "I'm neutral, but afraid of no one." So what it's trying to show you is the dogs were great dogs. They didn't bark at nobody, but then when all these fucking idiots got these dogs — excuse my language — in the '80s, and they started to train them for attack, they got poof! Forty years ago, people would have pit bulls, people didn't even know what they were, and that was the greatest thing. But then

people started to peddle the dogs to make a few bucks and that's it. Every decade there's a fad: the '70s was the Shepherds, the '80s was the pit bulls and the '90s became the Rottweilers. Now you got these, what are they called . . . ? Presa Canarios and Dogo Argentinos. You know, everybody's always into these macho, big strong dogs, you understand? It's taken a bit of the attention away from the pit bulls, but the problem is, all you need is one attack from a pit bull and it's front-page news. It can be fifty other dogs – Shepherds or Dobies – biting people all year long, and it might not even make the paper. Now, the reason for this is one pit bull attack will do the damage of fifty other dogs combined. It's like having a bb gun: you can shoot it all day long, birds this and that, you won't do harm. You take a machine gun and you go and shoot once; you know it's going to blow everything away. Same thing with a pit bull.

So banning the breed is not an option?

No. It's not an option. It's not a solution. Making pit bulls outlawed? Outlaws will still have them, you know? They tried to ban alcohol . . . it's a different comparison. . . . They banned alcohol, but because people wanted it, they got it. People, you know, even risked going to jail. Good law-abiding citizens drank Sundays with their fathers. And finally, they abolished it. They saw under controlled circumstances – you have alcoholics, you have drinking problems – doesn't mean that because there is alcoholism, that alcohol is bad. It's like saying if they legalized heroine or cocaine tomorrow, would you do it? No. There you go. I wouldn't do it. Most people

wouldn't do it. Just because it's legal, doesn't mean somebody's going to do it. But, and the point of the matter is, you have to have everything in moderation. People don't know their boundaries, and that is why some things should be outlawed.

Do you feel that dogfighting is fairly portrayed in the media?

No, not at all. I don't know where the media gets prostitution and dogfighting mixed up. A lot of the times, you read, "Dogfighting, Prostitution, Drugs. . . ." Now I can understand the drugs. They find, let's say, a joint of grass on somebody, and they mix drugs in there, and they say, "There is our proof; there's drugs there." But prostitution . . . what does that mean? That everyone that is there with a woman, that the woman is a whore? They put money laundering; they put all kinds of things. In reality, if you saw dog-fighting pictures from the '40s and '50s, it was all gentlemen – with suits, and hat and tie. Today, it's got a mix of people, but the truth of the matter is it's got a lot of shady characters, because it's the illegal people that are attracted to the illegal thing. Remember how Reagan's wife said, "Just Say No to Drugs"? The "Just Say No" wasn't working – you had to have a reason why to "Say No".

So dogfighting is illegal . . .

Yeah, and I agree with that, to a point. Because this way it's got some control. Because there's no governing body that says, "These are the laws, these are the rules for dogfighting." So it has to be run

by the people that actually do the dogfighting. But the point of the matter is it should be legal so that it's run properly. But if it was run properly and people got to see the way dogfighting is done — how it's pound for pound, how there's referees, how the dog . . . and the rules say it's a "scratch-in-turn" match, in other words, the dog has to show willingness to go, if he does not show willingness, the fight is stopped, even if the owner wants it to go on. It's over and done with. It's like a boxer that goes down for ten seconds; if he gets up at eleven and he still wants to fight, it's over and done with. Same thing with the dog. If he doesn't go across in ten seconds, the fight is over.

And you don't fight a fifty-pound dog with a thirty-pound dog, or even a fifty-pound dog with a fifty-one pound dog. It's two different classes. People don't know — the news media never puts this in the paper — that they are fought pound-for-pound, that if the dog turns his head and shoulders away from the dog, as long as they're separated, and that the dog has to scratch across [cross the center of the pit and willingly go into the other dog]. All these small mitigating factors are not mentioned. They just put, "Two dogs are put in there, and the owners cheer on their dogs while they rip each other apart." And this is what sells. Sensationalism sells papers.

Do you believe that dogfighting is cruelty to animals?

Not when it involves pit bulls, no. Because the dogs were bred by humans for over hundreds of years for this purpose. The dog, it knows

that its core being is to be a warrior. Just like a Beagle has been bred to hunt and a Labrador has been bred to retrieve.

I'll give you an example: a friend of mine breeds and sells Beagles. Hunting Beagles. He's got the small ones, you know? You got two different types: small ones and big ones. One day, I went to see him. I brought a customer to buy a dog to send to Europe and he took about seven or eight Beagles with him out to the field to show the guy how his dogs worked, and there was one Beagle that wasn't feeling too well, and he left it behind – he didn't want to take it out – and when we left, it was howling because he knew we were packing up the truck to go hunting with the dogs. When we got back, six or seven hours later, his wife said to him "Thank god you got back because this dog has not stopped howling." As soon as we got back, he stopped howling, because he knew that we had gone hunting and he wanted to come. He was crying all day. When we got back, he shut up. All the other dogs were barking that they had come back. He figured, "Okay, you're back, you're not hunting. I'm happy." You understand?

I see the same thing with the dogs up at the farm. They'll come out of the dogs' house with their chains – they're all up jumping high, happy and hyper – and if I take one off the chain and I start to walk to the back, and they see me take another one and walk it to the back, they know what's happening and they howl like crazy. As soon as I walk back with the dog, they shut up, 'cause you know they're howling, "Bring me! Bring me! Bring me!" It's not like they're howling and they're running away. They're howling and coming towards me.

If they were against it, or they were afraid, they'd be, you know, in their house, and quiet and very skittish, you know? But here, they're screaming and howling and wagging their tails to be taken along.

A guy once told me that if a dog doesn't want to go, you can't make it go.

That's right. If it's a "cold" dog, the dog can't go. It's like a guy who doesn't want to fight: if you keep fighting him, and you put his back against a wall and he gets hit, in the end he's gonna fight out of defense. But as soon as he gets out of danger, he'll run away, just like the dog. A cold dog will never start, you know? He can go even at four, five years old. He'll actually get bitten, too. He'll just sit there and wag his tail, or maybe not wag his tail, but sit there, and he won't start. And some of them can get bitten till they die, you know? There'll be a kennel accident and the dog won't fight, and it will die. That's a "cold" dog. It doesn't mean it's a cur. It's just a cold dog. Some of the greatest dogs today have come off of cold dogs. A lot of "Patrick" dogs are "cold" dogs.

So, it would be safe to assume that someone wouldn't match a dog that was —

You can't match a "cold" dog. But, it would be safe to assume that you don't breed to a "cold" male. But a "cold" female . . . it's been proven that "cold" females have produced, because they're throwing eight or nine dogs in their litter, you understand?

What books/magazines would you make a journalist or a novice bulldog fancier read? What would you make them read if they wanted to know "the real deal"?

Listen, Stratton puts out some good books, you know, for the novice, right from the beginning: "*The Truth About the American Pit Bull Terrier*" . . . and he gets right to the back. Now the guy is pro-pit bulls but he does give you the good and the bad of it, on everything. And then he's got books that go way off the pit bull, as a general book, where it's just the core of the dog, the nucleus of the dog, game warriors, the history of the dog, why they were bred, their breedings, their bloodlines and their achievements. And it makes you see that the dog was bred for this. We see the dogs enjoy what they're doing. People can't comprehend the fact that the dog, quote unquote, "enjoys this". They mix emotions with logic. They think, you know, "How can somebody enjoy getting bitten?" How does a boxer go in the ring and fight? He's not put in there by force. And he fights, and when he's had enough, you see that, you know, he picks up the towel, and throws in the towel himself. Same thing with the dog. He turns his head away; once he turns his head away, the fight is over. He's put in the corner to go crossing. He doesn't go crossing, and it's over.

Who's had the biggest impact on developing the breed?

As a breeder? As a country?

As a person.

As a person . . . I guess, you'd have to say . . . Tudor. Tudor was one of the greats, 'cause Tudor would breed, handle and match dogs, okay? At one time, he was such a top-notch dogman that he would lay stakes like "I will match three dogs in one night. If I lose one out of the three, I pay all three. I would have to win all three fights to be considered the winner." And he would tell you, "Give me three weights, and I'll come up with three weights, and you three different guys can come with three different guys or one guy with three dogs," or whatever, but that must beat one of his dogs. "If I lose to one dog, I lose all three fights." So you knew that he put his money where his mouth was, and he bred well-producing dogs. It's not only that he had good dogs; they kept on breeding and they produced dogs from the early '20s, all the way to the '90s, 2000. The dogs go back to the Carver dogs. Now Carver, too, was great for the pit bulls, and he had all Tudor dogs. After Carver got out of showing dogs, he was a breeder and the last twenty-five years before he passed away, he had a success rate of ninety percent . . . uh . . . eighty-seven percent winners. That tells you something about the dogs.

That's it.

But can I finish one thing?

Yeah . . .

There have been other breeders, modern-day breeders, non-breeders
and dog owners that have dogs that they don't breed. They just take
the dogs and show the dogs. They'll actually even go ahead and buy a
dog off of you, like a one-time winner. They like the dog; they win
two more matches and make him a champion, or four more to make him a
grand champion. Then they sell him. There are some guys that have had
a couple of dozen champions, but they've had acreage, space and time.
The only person, I think - not because I also idolize the guy - was
Giroux. The guy, in not even a dozen years - he passed away unfortu-
nately - bred and produced more champions, than anybody has from the
olden times to modern times. Until today, that record will stand and
will stand for a long time, considering the guy would breed a lit-
ter of dogs, and maybe keep one or two maximum. He'd farm one at your
house, another one at another house - rest his soul - and he'd get
champions out of just about every litter. The guy had a gift for dogs.
A gift! This is something else! I think the guy maybe metamorphosized
at nighttime into a pit bull - you know what I mean? - and spoke with
them. He's been dead now since '82 - that's twenty plus years - and
his bloodline's still running strong. Other dogs, like Tudor's and
Carver's dogs, are strong, but you gotta remember that this is a man
that lived in a house that had no acreage. He had one or two dogs in
the backyard, a couple dogs in the house and that was it.

That's it.

That's it? Okay, buddy boy.

BEWARE of DOG

By turf & tchug - *Two Dirty ol'dogz* -

- PITBULLS DON'T FEEL PAIN...

- PITBULLS ARE MEAN...

...REALLY MEAN...

THE END

"When is someone gonna do something about all the little out-of-control man-biters? Tell the 'powers that be' to look into all those little loud barkers and sneak biters. 'Cause they['re] Public Enemy Number One in my book."

Dudley Dobbs,
Bayridge, Brooklyn,
September 2002

EXPERIMENT A:

Ted
Power

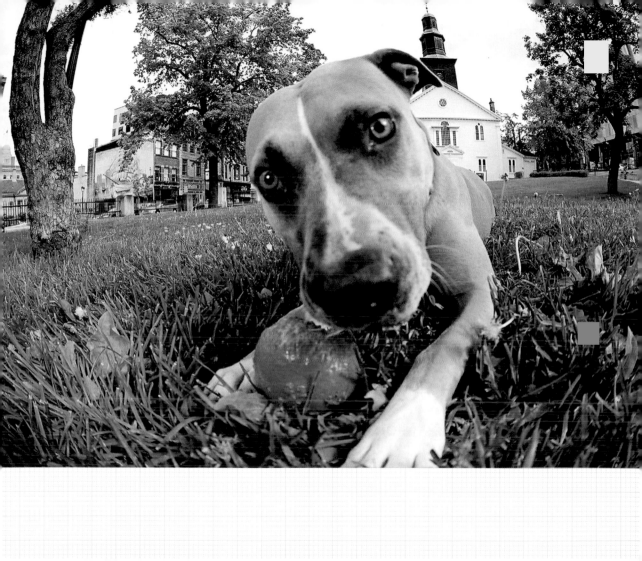

Dogs don't usually like skateboards. As a result, most people involved
with skateboards aren't very fond of dogs. I think this is funny. I find fear funny.

So I find a skateboard photographer. I find one who isn't comfortable with dogs.
I find one who's scared. His name is TED POWER. I ask him if he would like to shoot
photos of pit bulls for fun.
He says fuck no.
I taunt him.
He goes into elaborate detail about dogs chasing, snarling and lunging
at people he's photographed in the past. None of his stories involve bulldogs
of any kind, but he's bought into the media's rhetoric.
This annoys me.
We meet for pints.
Ted is heavily tattooed (so he has to have a reasonable pain threshold). He takes
photos of people on skateboards for a living. People often lose control of skateboards.
As a result, Ted's face has been bludgeoned on many occasions.
He's no stranger to pain.
I taunt him.
He still says no.
I taunt him more.
I put his skills in question. I'm condescending. I call him the five-letter word for cat
over and over again. I'm not a very nice person today.
Hours later, he's game.
He's scared, but pride is a funny thing.
We don't speak for a few weeks.
A package arrives in the mail. It's from Ted. There are contact sheets
inside, two dozen 8 x 10 prints. And a note that reads "I hate you. I was wrong.
I need a bulldog in my life. I shot a couple of dogs for fun and now I need my own.
Is there anything more perfect on the planet – anything more gentle, more beautiful?"

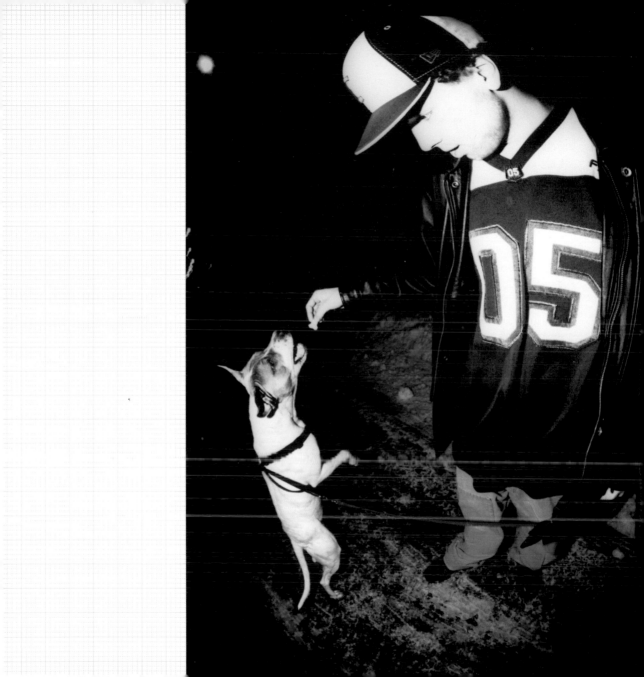

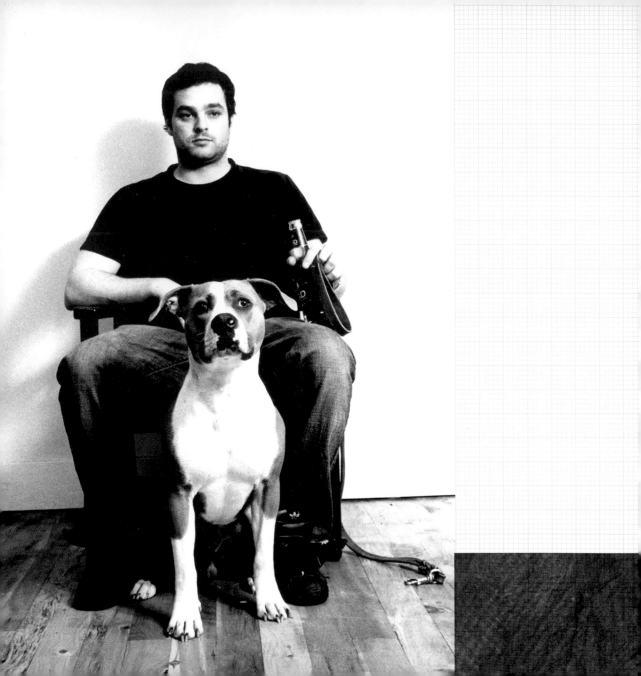

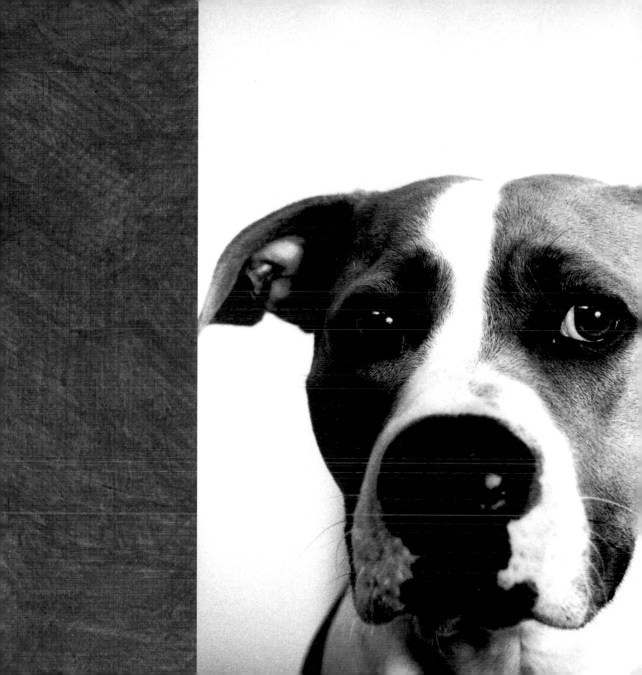

there are no animals in nufonia.
but if there were, they would be robot staffordshire bull terriers

kid koala

MOVIE IDEA #1

A movie about a young family in the city: A man, his wife, an infant and their loyal nanny dog.

Mother puts child to sleep.
Husband reads paper and nods off.
Dog goes into infant's room.
Mother does dishes.
Dog leaves child's room covered in blood.
Husband is woken up by bloody dog who leads husband into infant's room. The room is full of blood. The crib is knocked over. Man loses his mind, grabs dog and throws it against the hallway wall. Wife enters baby's room. Man picks up dog and throws him out the apartment window. Dog falls eight stories onto busy street. Dog bounces off the pavement before being hit by oncoming bus. Woman emerges from room with a healthy baby. Man enters baby's room for a second time, picks up baby's overturned crib to find not one but two dead, "baby-killing" venomous snakes and a dead alley cat. Man, though relieved that his firstborn is alive, crashes to his knees as he realizes that he has just murdered the bravest and most loyal member of the family. Man never speaks again.

Man realizes the error of man's ways.

MOVIE IDEA #2

Setting: The 1970s.

The Pitch:
It's a movie about a boy and a dream. A film about decision.

The boy's dream is to have his own yard to develop and breed his own line of American Pit Bull Terriers. He wants to breed real game dogs like those from the past. He leads a modest life, doesn't have much money and even less room. He befriends a man in the street. A man who once had a yard of great dogs. A man who is no longer involved with the dogs. Soon, the man takes the boy under his wing and schools him on the world of the APBT. He schools him on "the way it was". Years pass and the man calls in a favor and gets the boy a nice puppy bitch. A puppy bitch with great promise and great lineage. Several champions and grand champions in her pedigree. When the dog reaches two and a half years of age, the boy starts to ponder whether or not he should roll her. On one hand, having a winner and eventual champion will make her a more valuable dog for breeding. But if she curs, the dog is worthless. It's a movie about decisions. A movie about wanting to preserve a tradition in a time when fighting dogs is outlawed. A time when a dog's work apparently no longer matters.

MOVIE IDEA #3

Working title: The Bootlegging, Loansharking Dog Thief.

It's a film noir; it's a caper film.

About a man who dominates the pit-dog world by breeding and conditioning incredible dogs, and stealing anything that's better. He's a gangster in a world of gentlemen, where intimidation definitely reigns supreme. Might makes right. Set in the United States, the film should span the 1920s, '30s, '40s and '50s. The man is a bootlegging, loansharking dog thief. The hook is that everyone loves him.

SHORT FILM IDEA:

Handsome, low-key body builder/health nut type walks his bulldog down busy street. He turns on to side street and is entering apartment building when he crosses another man with a bulldog. The stranger asks him if he wants to let the dogs scrap in the park across the street. The body builder replies, "How about we just tie the dogs up and I bounce you around a little . . . ?"

They exchange words. The dogs get tied up and the stranger receives the thrashing of his life . . .

The body builder is arrested and spends a night in jail. He has peace of mind in knowing his bulldog is safe at home with his girlfriend.

MOVIE IDEA #5

Present Day.
Setting: The Midwest. Rural community on outskirts of big city.

An introverted, outcast 12-year-old boy and his shelter-adopted APBT (peas in a pod right?).

The two become inseparable. The dog fills a much-needed void in the boy's life. The dog, who has Lassie-like intuition and a great affinity for the boy, spends his time getting the boy out of whatever highjinks the day brings. The dog spends his downtime earning points towards his super dog title, doing therapy work and making headline news running into burning buildings and saving the elderly. The dog will not speak but his thoughts should appear subtitled throughout the film in a foreign language, even though the actors will be speaking in English.

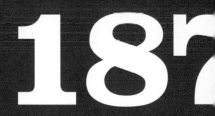
187

Pit bulls get a pretty bad rep. You always hear about some Pit that did this or did that on the news. Whenever I tell people that I have a Pit they give you this look as if to say "are you sure that's safe?" I will be the first to say that Pits can be dangerous, but so can a Jack Russell if it is trained to be. There are many dogs like my Vino, who would lick you to death before attacking you. If you give them love, they will love you right back. Vino is a 75 lb. white Pit that grew up from being the runt of her litter. Luckily for her she showed no signs of her adult strength and size as a pup. Vino was bred to be a fighter, and was sold by her mother's owner when she was a puppy. When she didn't grow fast enough the buyer returned her to the breeder's garage in Brooklyn, where she lived by herself for several months. My friend, Rene, an animal rights activist, lived next to the garage and could hear Vino crying from behind the metal pull down every time she passed. She approached Vino's owners and after months of pestering finally convinced them to give "Pinky" to her. My sister and I picked Pinky up the day after returning from an Italian holiday during which we drank too much wine. About twenty minutes after meeting her we changed her name to Vino, but it only took a fraction of that time to fall in love with her. Vino is about the sweetest thing alive, but sometimes that vicious reputation can work for you when you live in Bushwick, Brooklyn. Bushwick is infamous for being one of the most undesirable sections of Brooklyn . . . likewise it is also a renown site for the Williamsburg gentrification overspill. Either way it's an ideal place to walk around with a 75 lb. set of teeth on a leash. One time I was a couple of days late with the rent. My sister lost her mind demanding that I go get the money immediately as I was leaving town the next day. The problem? It was 1 a.m. and the ATM was on the other side of a housing project. Now, I had never had any problems in my neighborhood, but I am thinking "watch shit go down now, when I have $500 in my pocket." Then it occurred to me! I'll just bring the dog! No one will mess with me then. Shit, most people cross the street when we are out for a walk. With Vino in tow I hit the street all hoodied down to look as tough as possible. I will admit it every time, I was shook as hell! We started on our mission, quickly making it through the housing project and to the cash machine without a hitch. I grab the money out of the cash machine and head home walking as fast as possible without looking like something is going on. I really wanted the whole ordeal to be over. Halfway through the project I can see the end of the block and I start feeling like everything will be cool, then a guy appears out of nowhere across the street. He starts yelling something, but at this point there was no way I was stopping for anything. Vino is not as smart though. She bounces around to look at him wagging her tail like a maniac. I am jerked back and stop. At this point the guy starts saying some other shit, and I started freaking out a bit. Instinctively I pulled on Vino's choke collar, and just thought over and over again "just act mean this once!" All of a sudden she stopped wagging and got into her stance and shot the guy a look across the street. I don't know if it was the "don't mess with us" look, but it was enough for him and he disappeared back into the shadows. I turned around and just started pulling her down the street. Her eyes were still glued on the street he walked down. Everyone in New York knows that a neighborhood's mood can change by simply being on opposite sides of the street. I was never happier to be back on my block with my bitch. Vino is a big wuss, but I am sure if push came to shove she would be looking out for me and my sister. I just wish Vino was around the night I fell asleep on the L train and my iPod got vicked, that sucked.

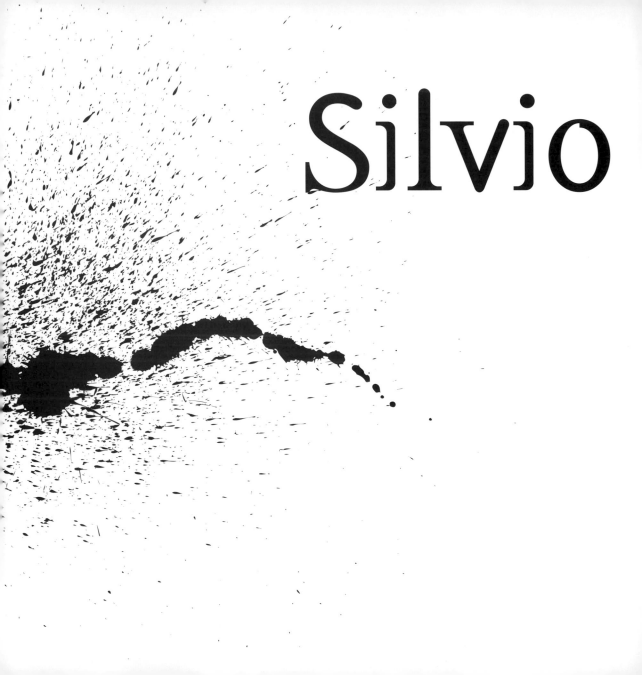

Silvio

Magaglio

Born in Paris in 1975, Silvio started taking pictures in 1992. In 1996, he started making photos for a French hip-hop periodical called *Radikal*. He shot graffiti at first but got more interested in taking portraits of the people behind the paint cans. And that is where his adventure began.

When I told him about this project and how I wanted to include some of his work, his response was "yeah, I guess that would be cool, but what you should really do is go around and interview all the mothers."

"The mothers," I said. "What mothers?"

"All the mothers who were opposed to their sons getting pits. All the mothers who fell in love with the pits. All the mothers who now take care of the pits because their sons no longer care. You should interview all the middle-aged women who walk and feed these magnificent dogs."

The photos in this section were taken in Paris in the late 1990s, as the Bully breeds were becoming popular with a new generation of the city's youth.

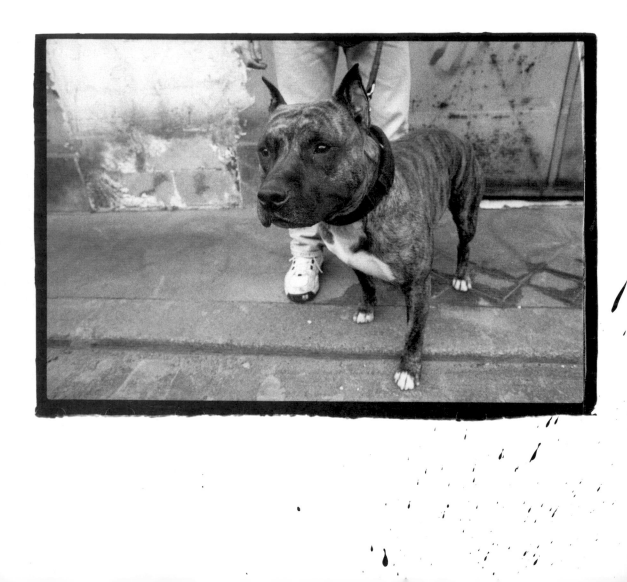

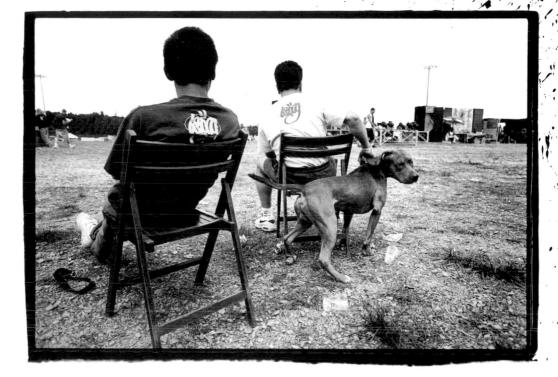

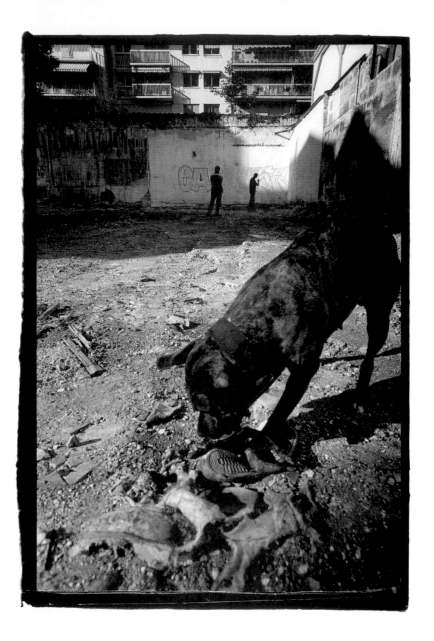

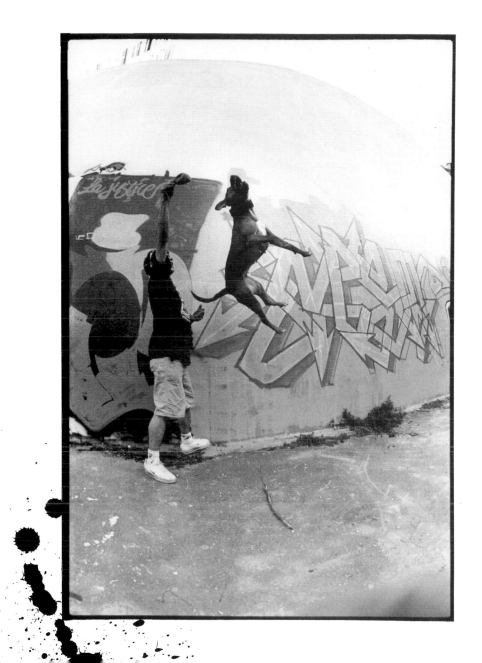

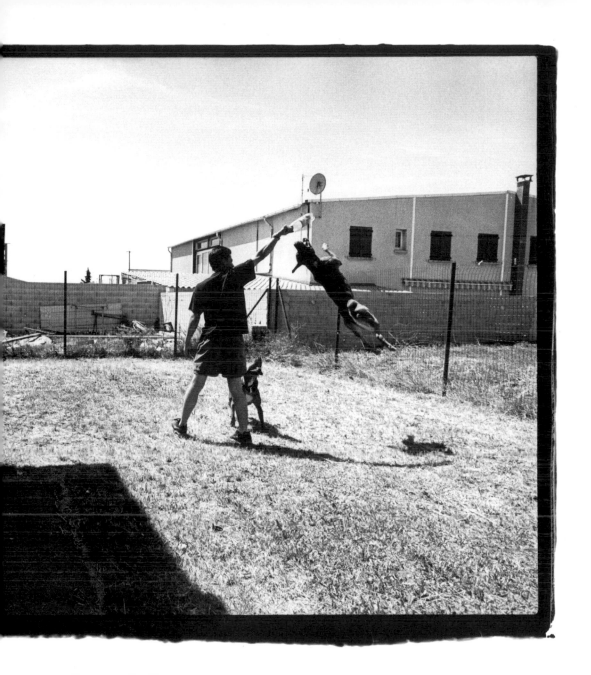

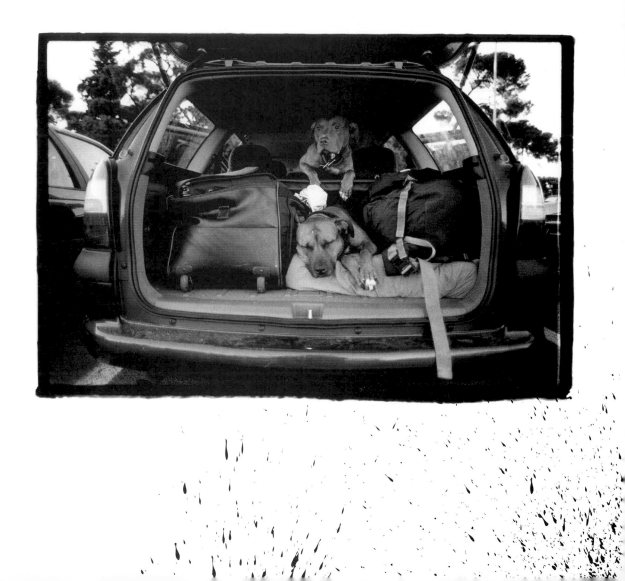

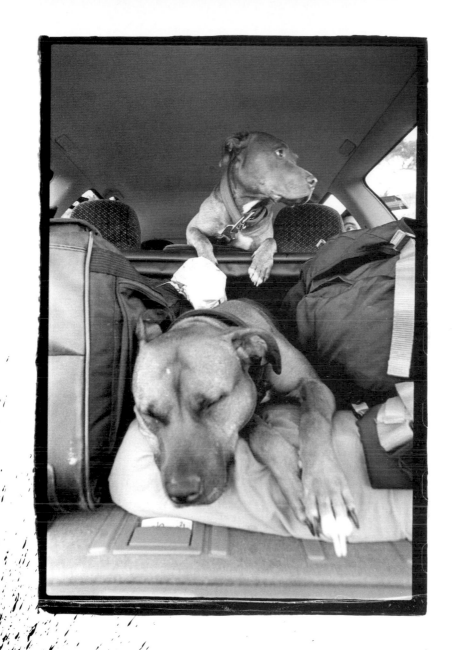

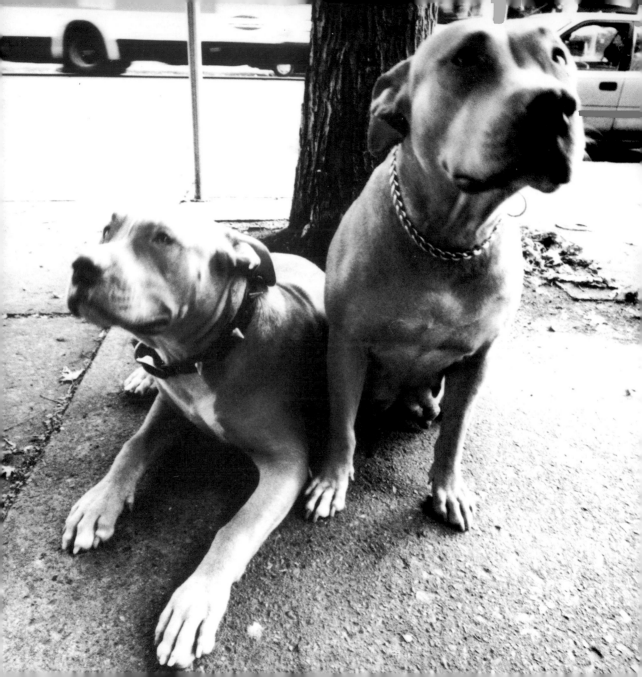

209

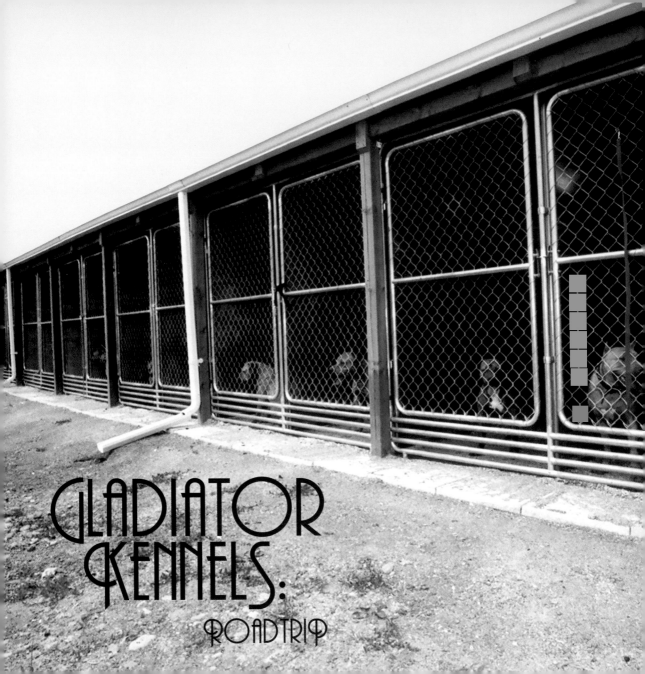

GLADIATOR
KENNELS:
ROADTRIP

MAY 2004

I had never been to a real dog kennel before today.
I was told to expect crummy conditions, a big stench and an even bigger mess.

I arrive unannounced at Gladiator Kennels at roughly 11 a.m. It's ok; they told me I could drop by any time. When I get there, I can't believe my eyes; it's an incredible facility. There is a barn that has been converted into a heated indoor/outdoor kennel facility. Each dog has its own space and decides when it wants to go inside or out. The dogs are all given a good daily run and are visited regularly by a dog trainer who evaluates the puppies and trains a select few for protection work. The dogs that aren't selected for protection training are sold as family pets. Shane, the owner, encourages his customers to enroll in obedience classes. "Every dog has a right to an education," he insists.

Gladiator Kennels specializes in red nose pit bulls. But more importantly, the goal of the operation is to breed bright, good-natured, hard-working, aesthetically-pleasing dogs with a high prey drive. Shane says he "breeds dogs that act like dogs but move like cats," a claim that I can't get my mind around until I witness dog after dog get their afternoon run. The dogs look magnificent. They are big (some close to seventy pounds) but they are agile, fast and have incredible leaping and gripping ability. They really do move like big game cats.

Gladiator Kennels was a refreshing change: a breeder with a breeding program that is pushing the breed forward in positive ways – the perfect balance between a dog that is bred for conformation and a dog that is bred for its working ability. Add to that the foundation of their breeding stock, which is wilder/hemphill and sarona blood, and you have a winning combination.

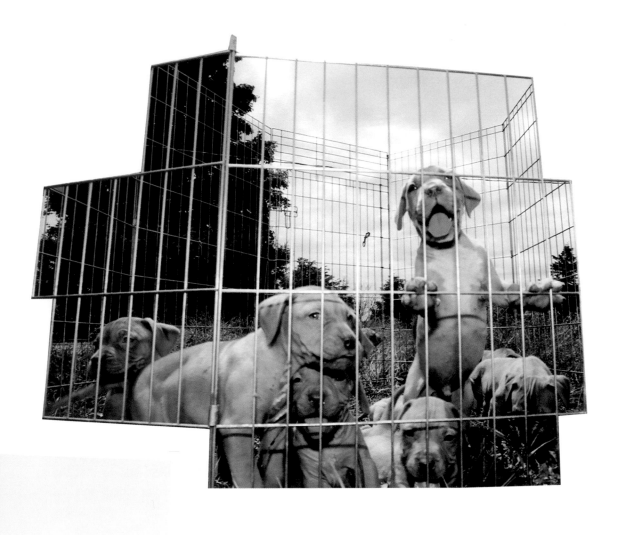

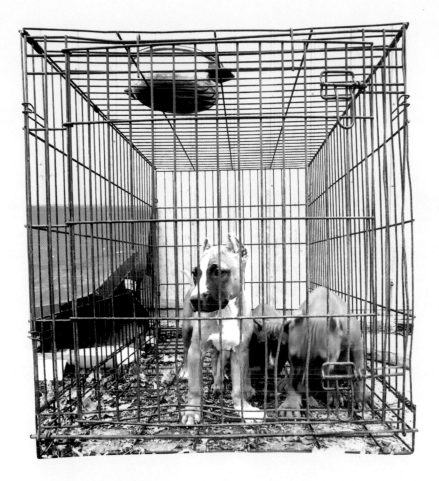

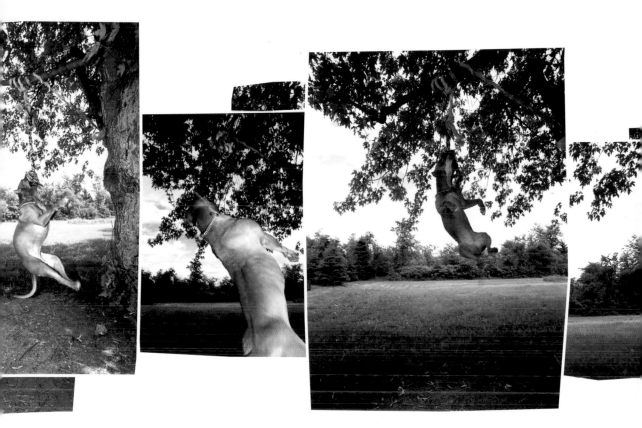

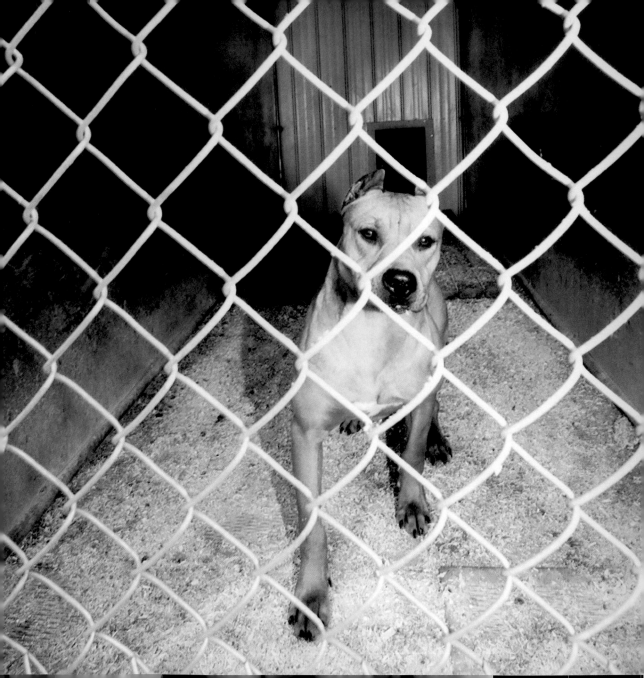

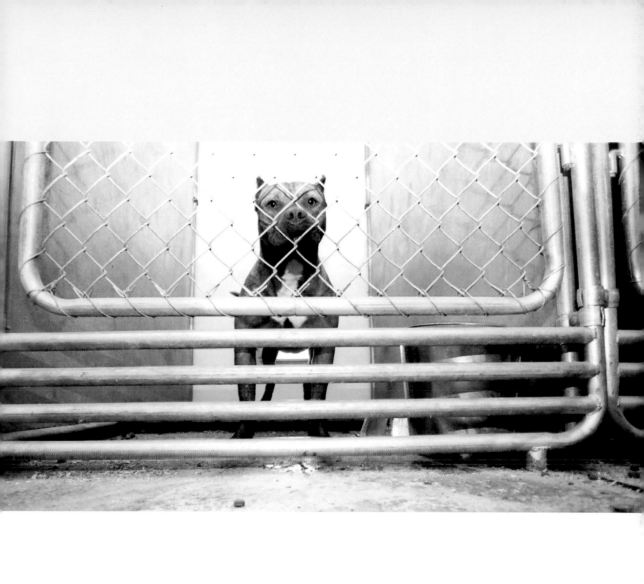

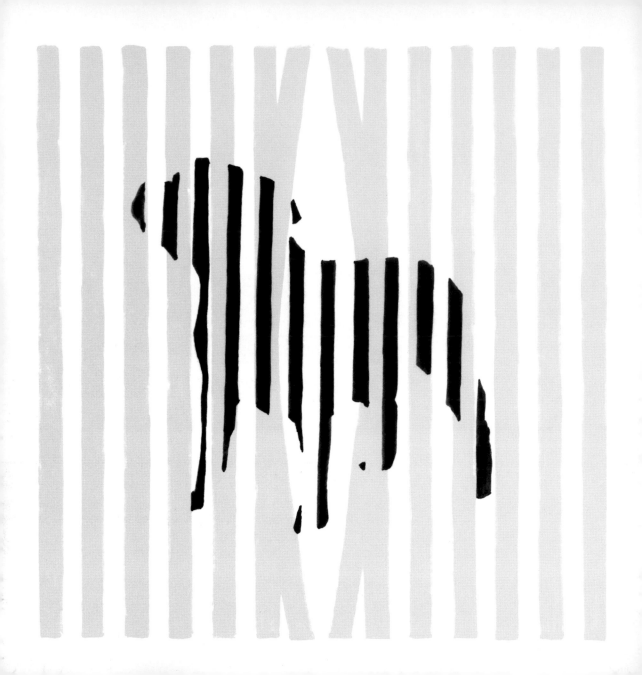

About Marco

Marco graduated from the Illustration program at Sheridan College in the spring of 2001.

He is currently a freelance illustrator and graphic designer who counts among his clients *Maclean's*, *The Financial Times* (London), *Outside*, *Mass Appeal* and *Runner's World*. In addition to these clients, he has helped develop and brand *Alena* skate shop with design work, and helped organize and curate a series of art shows in the shop.

Marco's work has been recognized in national and international publications such as *Applied Arts*, *American Illustration*, *Juxtapoz*, *Bail* and *Arkitip*.

The game of tennis, and the subculture that has sprung up around it over the last half-century, has had a profound influence on Marco's work. "It all stems back to the tennis tournament I won as a teenager," he says. "I mean, I only won because I was the only one who showed up in my age group, but I hung out all day, got a trophy and fell in love with the scene."

Raised in Montreal, he now lives and works in Toronto, Canada.

Illustration - www.workbymarco.com
Nove Studio - www.novestudio.com

About Paul